W9-AHU-821

RESCUE TAILS

RESCUE TAILS

Portraits of Dogs and Their Celebrities

BRIAN NICE

SIMON SPOTLIGHT ENTERTAINMENT

New York London Toronto Sydney

SIMON SPOTLIGHT ENTERTAINMENT
A Division of Simon & Schuster, Inc.
1230 Avenue of the Americas
New York, NY 10020

Copyright © 2009 by C.B. Kennebeck Inc.

All rights reserved, including the right to reproduce this book or
portions thereof in any form whatsoever. For information address
Pocket Books Subsidiary Rights Department,
1230 Avenue of the Americas, New York, NY 10020.

First Simon Spotlight Entertainment trade paperback edition November 2009

SIMON SPOTLIGHT ENTERTAINMENT and colophon are trademarks of Simon & Schuster, Inc.

For information about special discounts for bulk purchases,
please contact Simon & Schuster Special Sales at
1-866-506-1949 or business@simonandschuster.com

The Simon & Schuster Speakers Bureau can bring authors to your live event.
For more information or to book an event contact the Simon & Schuster Speakers Bureau at
1-866-248-3049 or visit our website at www.simonspeakers.com.

Designed by Kyoko Watanabe

Manufactured in China

10 9 8 7 6 5 4 3 2 1

Library of Congress Cataloging-in-Publication Data

Nice, Brian.
Rescue tails : portraits of dogs and their celebrities / by Brian Nice.
p. cm.
1. Dogs—Pictorial works. 2. Dog rescue—Pictorial works. 3. Celebrities—Portraits.
I. Title.
SF430.N53 2009
636.7092'2—dc22 2009022985

ISBN 978-1-4391-5276-8
ISBN 978-1-4391-5976-7 (ebook)

The author is donating 62.5 percent of his royalty advance for this book, and 100 percent of any additional royalties from the
book (in both cases net of literary agent fees), in equal parts to the Humane Society of New York and Much Love Animal Rescue
in Los Angeles. These are no-kill shelters dedicated to helping animals in need of medical care and new homes.

To my beautiful wife, Courtney, thank you for being so supportive;
my amazing daughter, Sam; and of course our dog, Buster

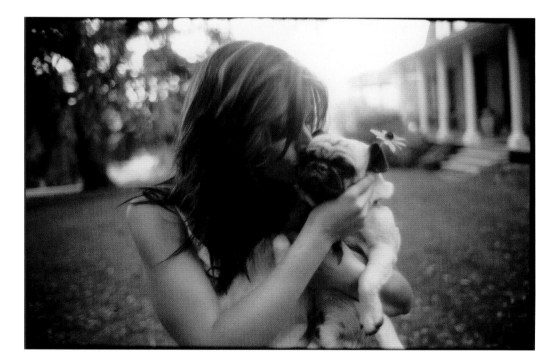

And in memory of my aunt, Barbara Morancey ("Tia"),
who loved and helped animals all her life

FOREWORD

Beth Ostrosky Stern

NEARLY EVERY TIME I speak to someone who's rescued a dog, they can't help but tear up and tell me, "I didn't rescue him. He rescued me." As the proud spokesperson for the North Shore Animal League America, I hear this very often—and I know exactly what they mean.

When I was growing up, my family only rescued our pets. Our first rescued mutt, Suziedog, brought every one of us unconditional love and joy for fourteen wonderful years. Our lives were blessed because she was part of our family. If you walk into any shelter, you'll find dogs who desperately want and deserve a great home and a loving family. It's as if they're just waiting for an invitation to make someone's life fuller, brighter, and happier.

Yet despite all the amazing perks a dog can offer its owner—excited greetings, funny bonding moments, countless tongue baths—approximately 4 to 7 million dogs are living in shelters and about 5 million more are abandoned every year. While wonderful organizations across the country both house and care for these animals, the number of dogs who need a home far exceed the number of shelters in America and the resources they can provide, and because of that, more than 3 million dogs are euthanized in the United States every year. Brian Nice and I share the belief that it's really important to raise public awareness of the great work that shelters do, the dogs who need homes, and how much of a difference just one person can make in a dog's life.

When Brian asked me to be in the company of this book's prominent subjects and their beloved pets, I was truly honored. Let's face it—he takes beautiful pictures. But turn to any page in this book, and you'll see how brilliantly he also captures the magic between dogs and their human companions. His love for and dedication to animals is obvious. Brian is an angel among us, and I'm so glad to have been touched by him. You will be too.

I hope you enjoy this book as much as I enjoyed being part of it. Thank you, Brian, on behalf of all the animals that will benefit from your passion project. You are an inspiration to us all!

INTRODUCTION

OVER THE YEARS I've learned that there are countless ways in which a dog can make a difference in a person's life. There's the unconditional love that a dog offers his owner every minute of every day; the laughter a dog brings her owner by just, well, being a dog; the sense of responsibility an owner gets from taking care of another being; and, as proven by my pug, Buster, who proudly graces the cover of this book, sometimes a dog can take its owner on a three-year photographic adventure across the country.

You may or may not be able to tell from the way he's looking at you, but about five years ago Buster went blind. I asked a friend of mine at the Humane Society of New York if she thought anything could be done to restore Buster's sight, and she recommended a doctor who ended up saving some of the vision in his right eye. As a way of saying thank you, I donated one of my photographs to the Humane Society of New York for them to auction off at one of their fund-raisers. The print sold, and the proceeds went toward helping many dogs in need of rescue. (In case you're wondering, the photo that was auctioned is the one on the cover of this book. And no, I don't dress Buster in my hats regularly—just when I go surfing, so he knows I'm coming back.)

With Buster once again healthy and happy and numerous dogs being helped by the sale of a single photograph, I thought, Why stop there? and I resolved to put together a book of photographs and donate all of my proceeds to no-kill shelters. My wife, Courtney, observed that the only thing people love more than photos of dogs are photos of celebrities, and suggested that I start photographing celebrities with their dogs. So every time I worked on a commercial shoot, I'd try to track down celebrities through my friends and colleagues and photograph them with their dogs. Courtney was right—it was a perfect combination. Later as I put together the book, the celebrities and two shelters, the Humane Society of New York and Much Love Animal Rescue in Los Angeles, went above and beyond, providing quotes about what their dogs have done for them over the years and offering advice for rescuing and caring for pets.

For three years I drove people crazy, asked for a lot of favors, slept on my fair share of couches, and logged a significant amount of time in rental cars. During this period I met with willing celebrities whenever they had a chance, wherever they felt like meeting, and with whatever toy their dogs felt like bringing on that particular day. I'd show up with my Leica M6 camera and a pocketful of black-and-white film, and for fifteen to thirty minutes, the dogs ran the show. The result is an eclectic mix of familiar faces, people who unabashedly love their dogs and who want *every* dog to have a good home and a good life, and who know that you can rescue a dog, you can take care of a dog, and you can love a dog, and that dog will rescue, care for, and love you right back.

I'm grateful to Buster for teaching me this lesson, and I'm grateful to you for buying this book and, in doing so, helping to save a dog.

RESCUE TAILS

Jack Johnson, singer and songwriter

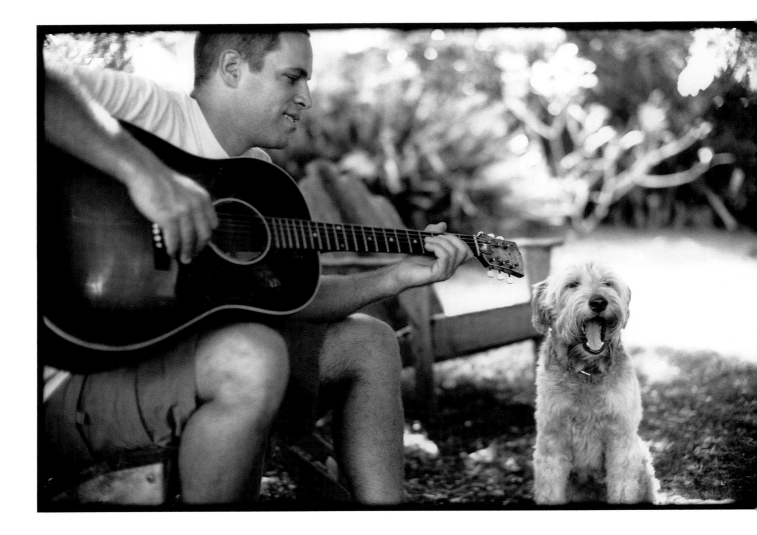

It's not all about puppy love. Adopt
an older dog, and you'll get loved
back more than you ever imagined.
—THE HUMANE SOCIETY OF NEW YORK

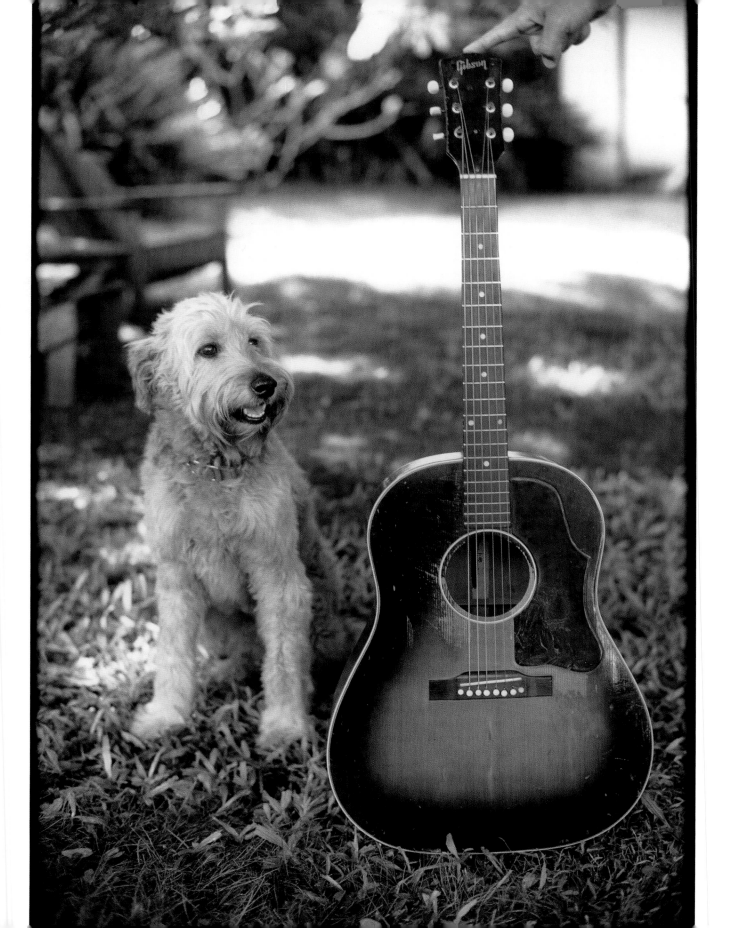

Vincent, dog seen on the television show *Lost*

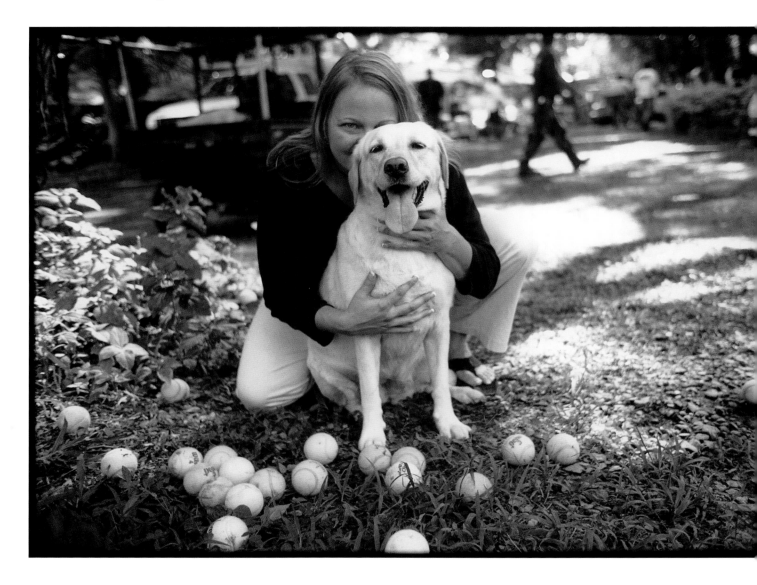

*"I could have been 'just a dog' to someone,
but instead I got to be part of a family."*

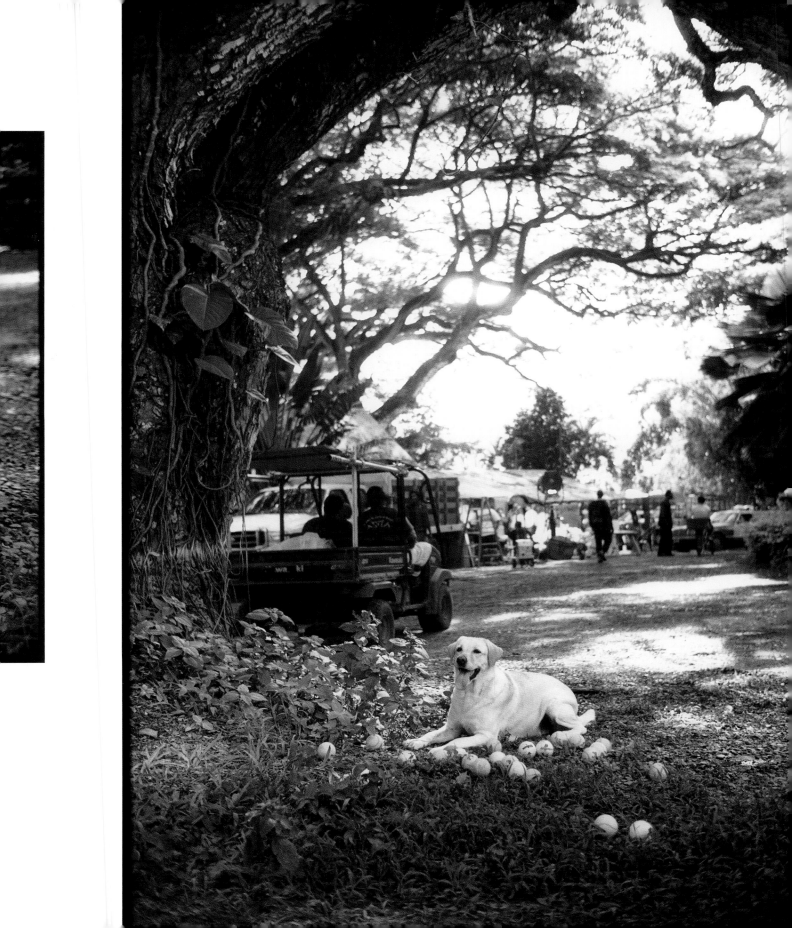

Kala Alexander, surfer, leader of the Wolfpack, actor

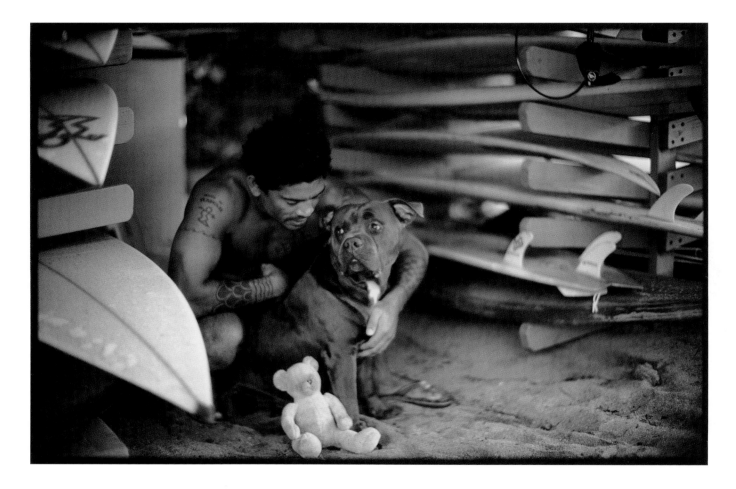

"My dog gives me unconditional love."

Kala Alexander

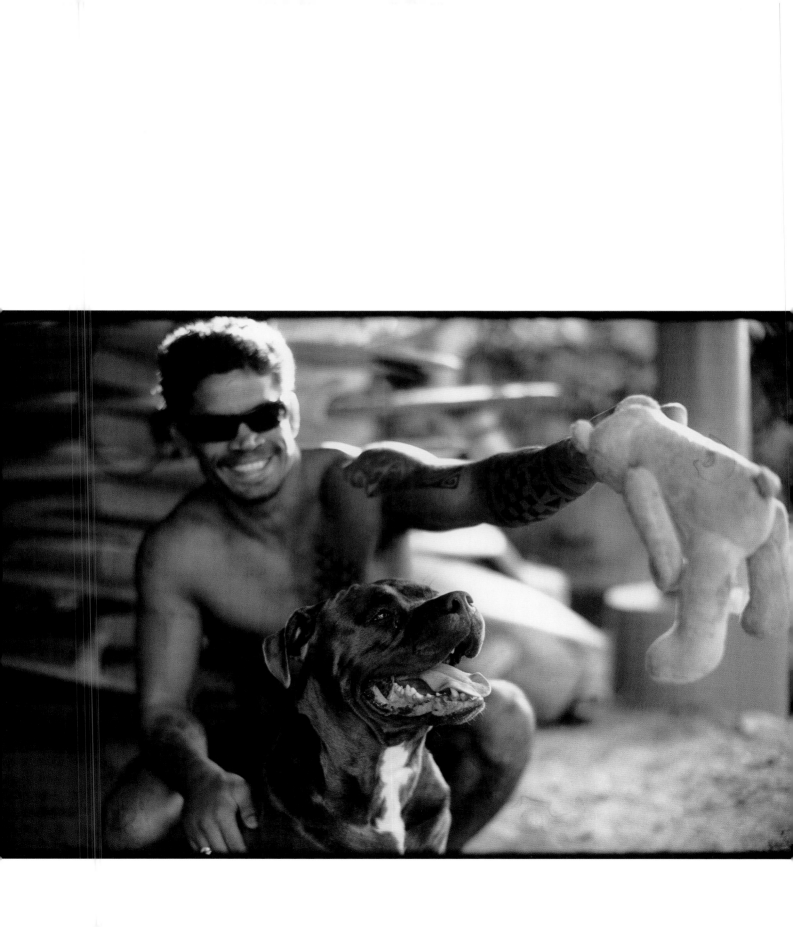

Susie Park and Leo Lee, actors

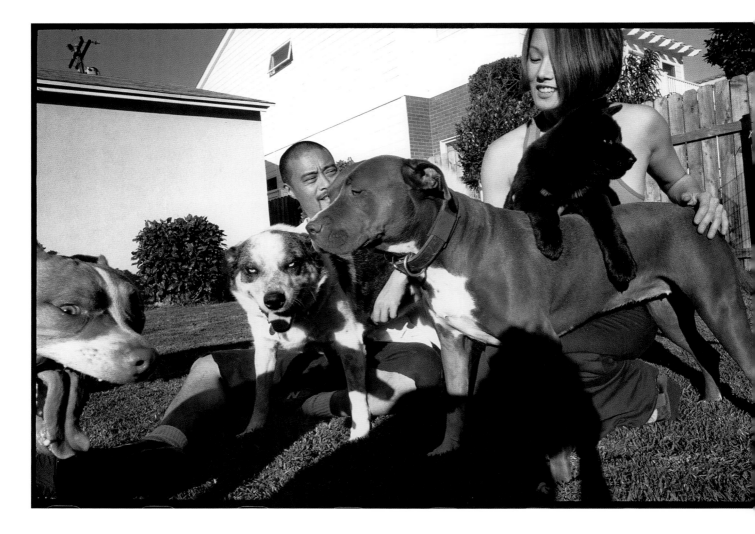

"Our dogs help us decide what car to buy; understand that farts are normal; know that we are never alone, ever; connect with our hearts; and feel that we are loved and appreciated."

Susie Park & Leo Lee

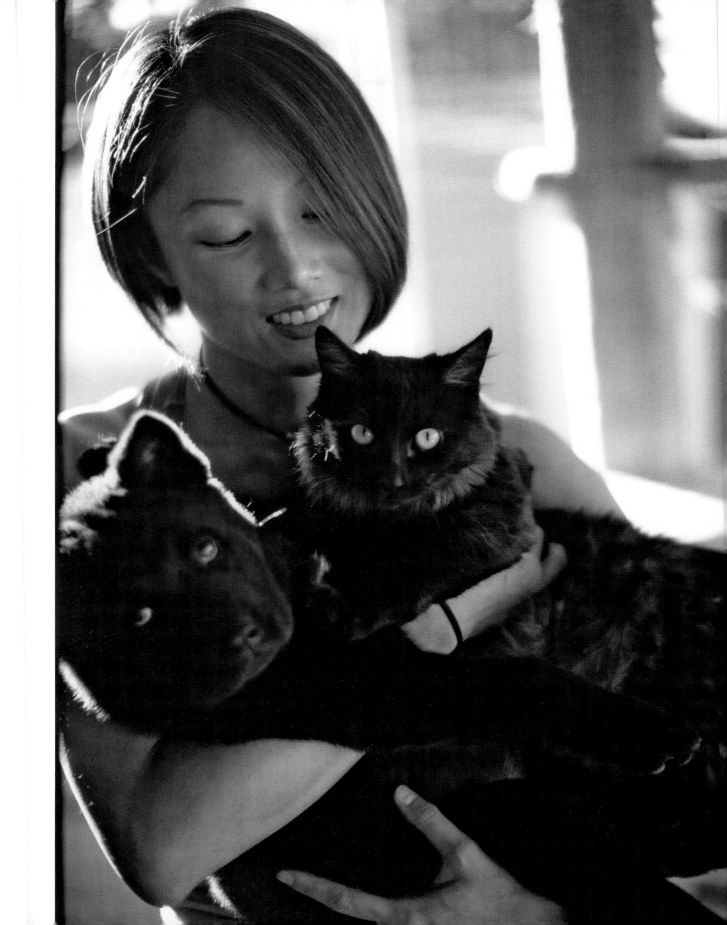

India Hicks, model and TV hostess, and
David Flint Wood, designer

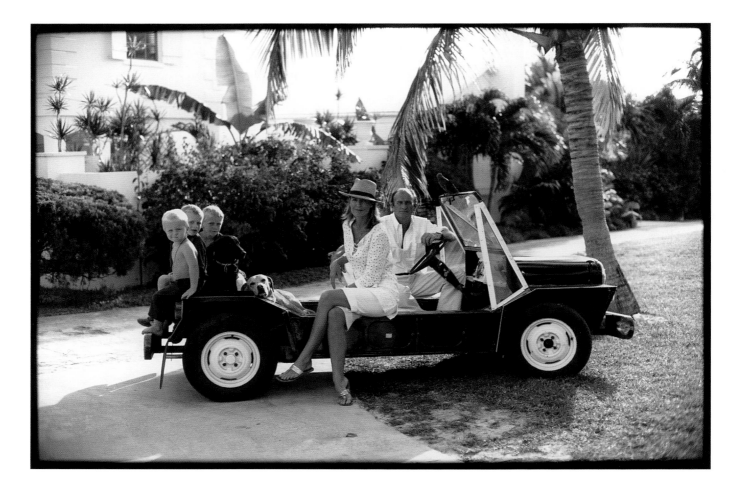

*"Barrel, who refused to be intimidated
by age, had the politeness of kings and
a healthy attitude toward life."*

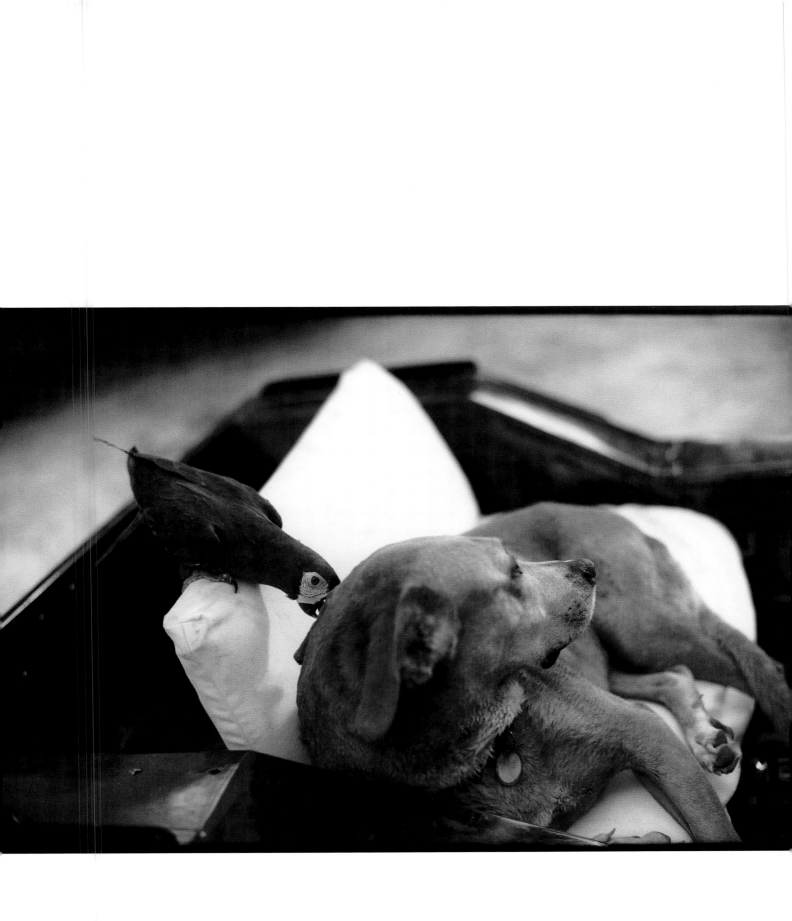

Cameron Mathison, actor

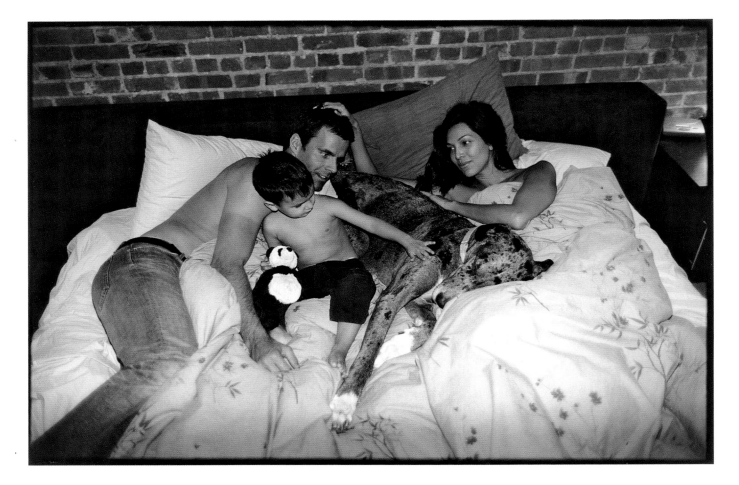

When you're ready for a new family member,
find a quality breeder or adopt from a reputable
source. Don't support pet shops and puppy mills.

—THE HUMANE SOCIETY OF NEW YORK

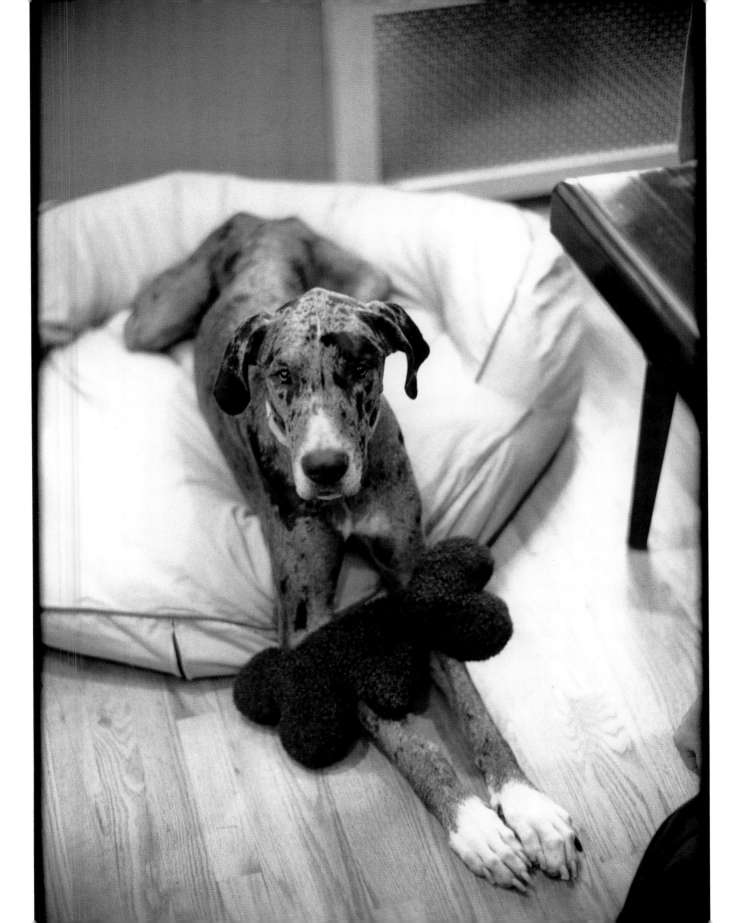

Paul Teutul Sr., founder of Orange County Ironworks and Orange County Choppers

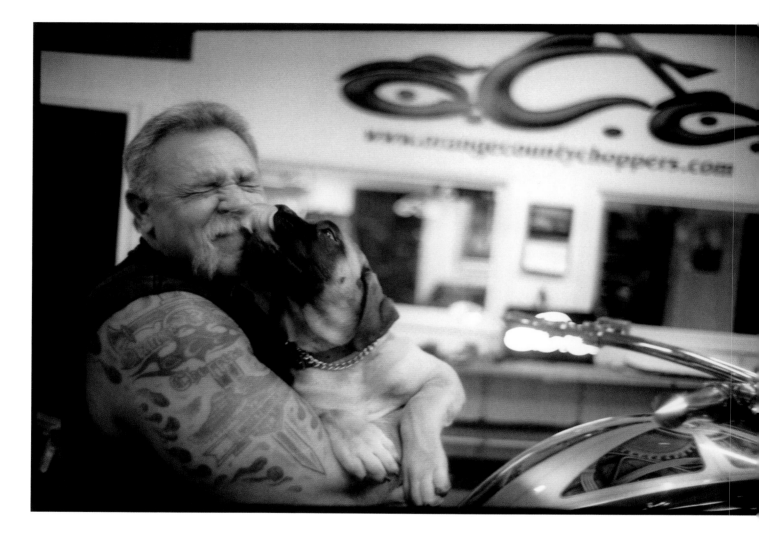

Paul SR
OCC

Teaching children about animals instills respect and can prevent animal abuse later.
—THE HUMANE SOCIETY OF NEW YORK

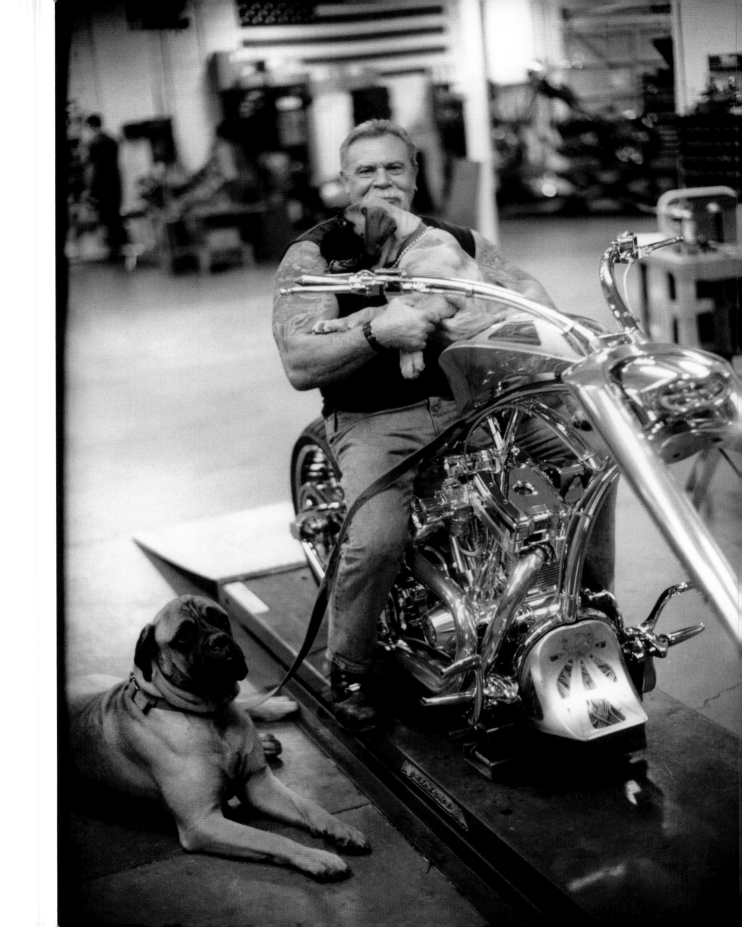

Tommy Hilfiger, fashion designer

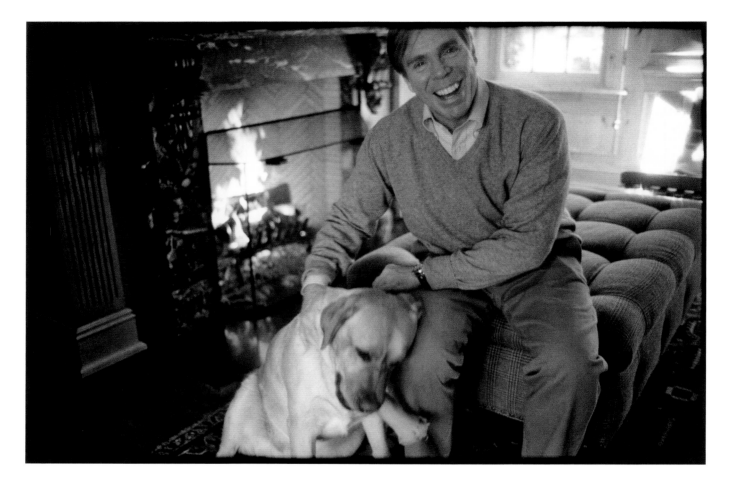

If you like the idea of living
with a little kid who'll never
grow up, get a job, help pay
the bills, or even take out the
garbage, then congratulations,
you may be ready for a dog.
—THE HUMANE SOCIETY OF NEW YORK

Andrew Keegan, actor

One Love,
Andrew Keegan

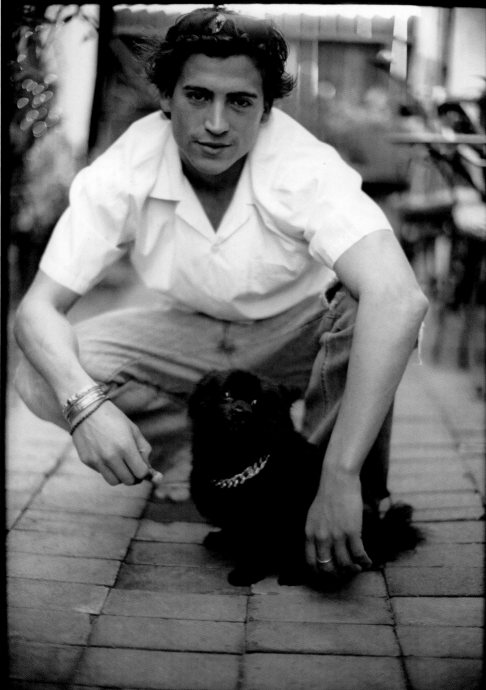

You may think she's a genius, but your dog can't be responsible for her own health and nutrition. It's up to you.

—THE HUMANE SOCIETY OF NEW YORK

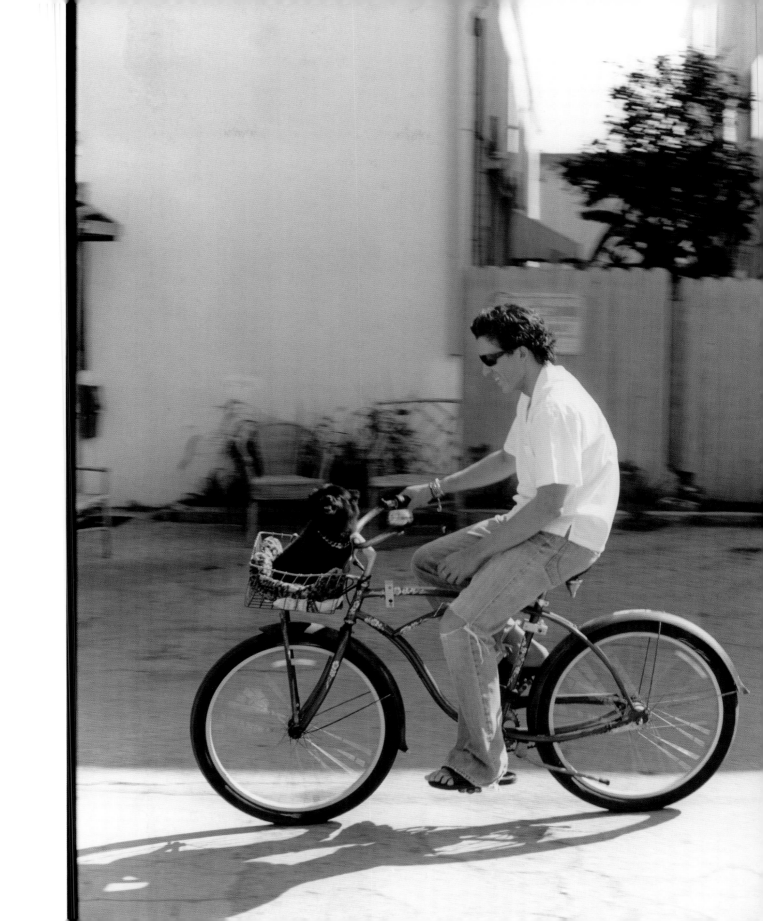

Shannon Elizabeth, actress

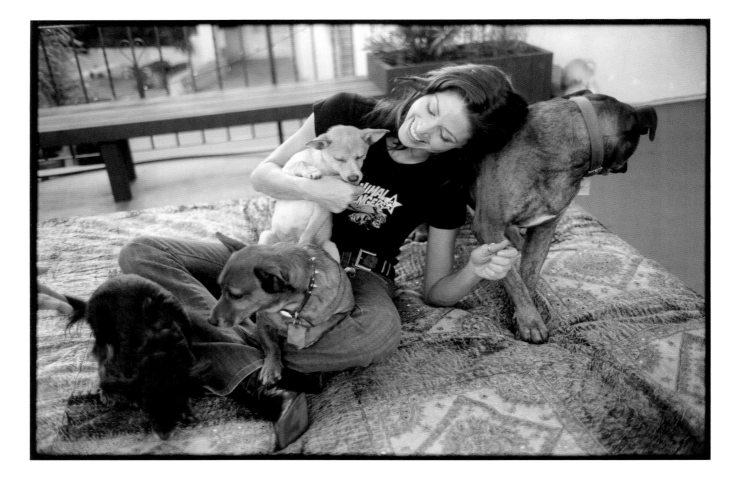

"The love that my dogs give me is the most consistent thing in my life.
No matter how bad my day is or how sad I might be,
they always bring me happiness and kisses."

Mariel Hemingway, author and actress

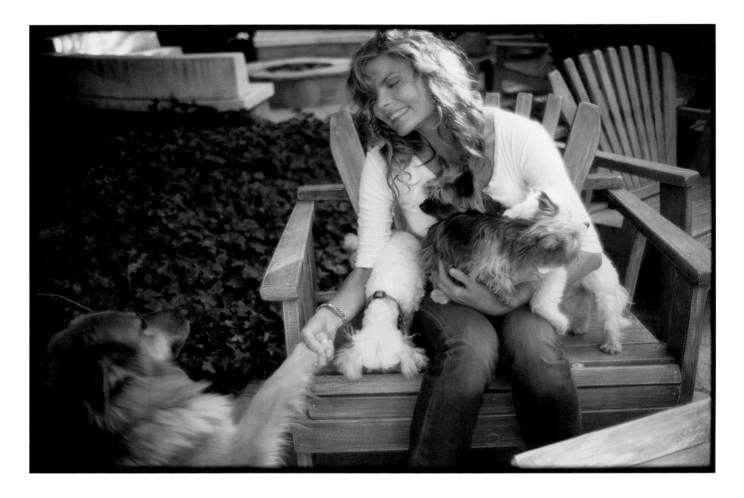

"My dog reminds me what it means to be present,
and that you can be loving all the time."

Tatjana Patitz, model and actress

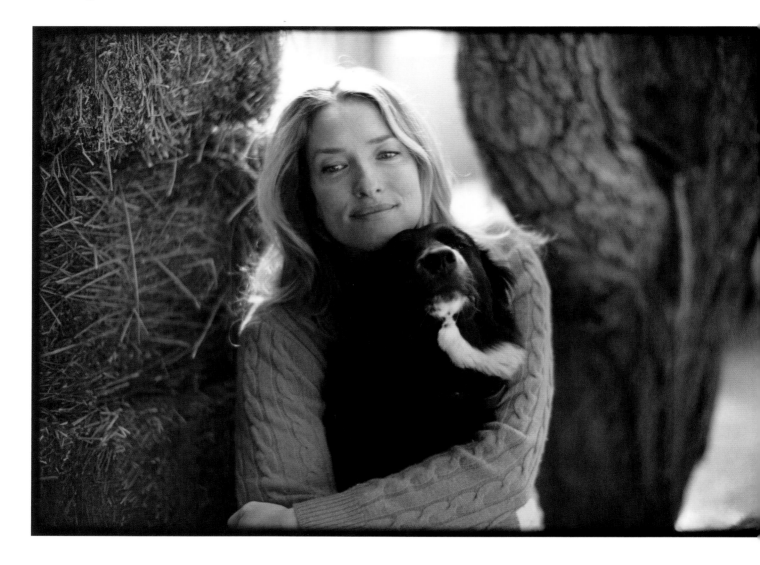

"To me, dogs are furry angels and masters of unconditional love."

Tatjana Patitz

Danny Aiello, actor

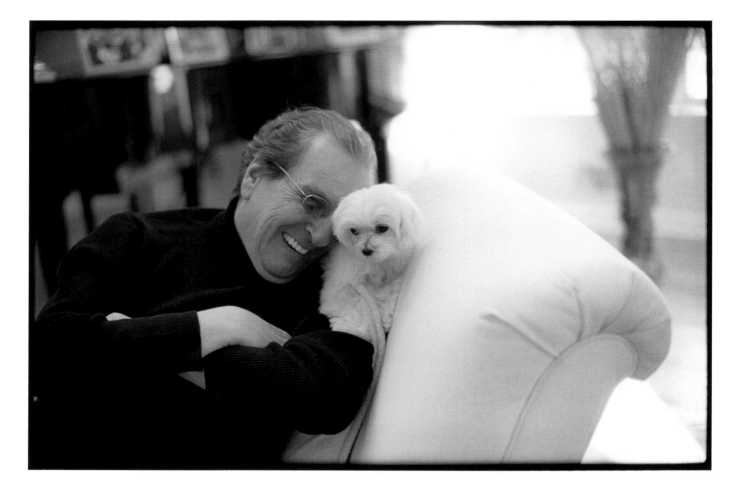

Don't forget to microchip your dog. If he ever gets lost, a chip will be
your best friend's best protection, helping him find his way home.
—THE HUMANE SOCIETY OF NEW YORK

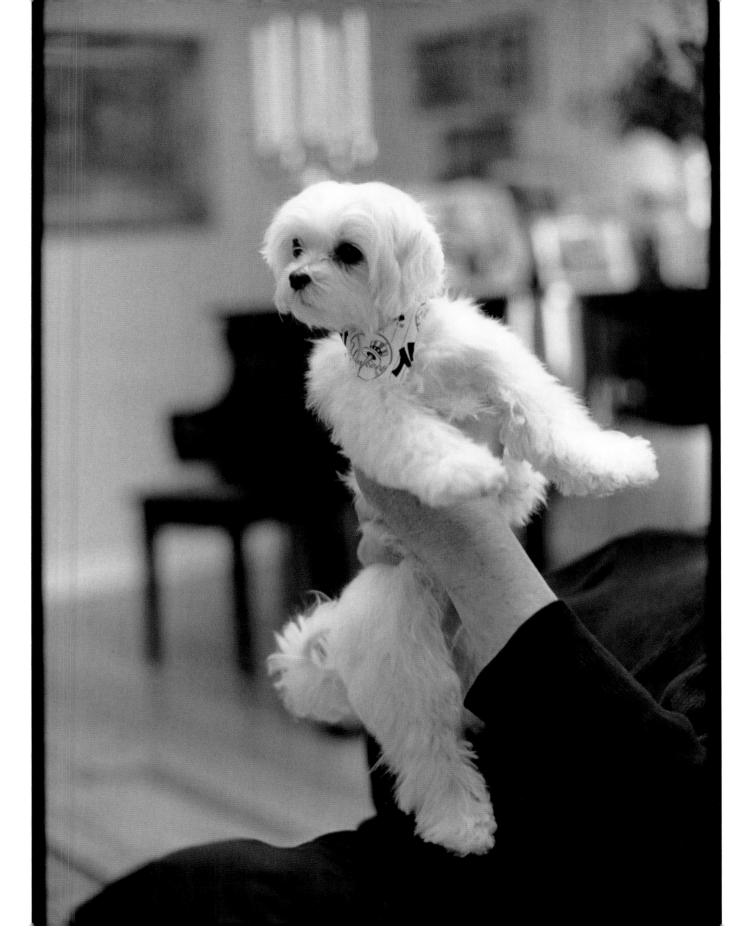

Jace Panebianco, professional windsurfer and cinematographer

"Blue Dogg has taught me how to slow down and enjoy the little moments in life."

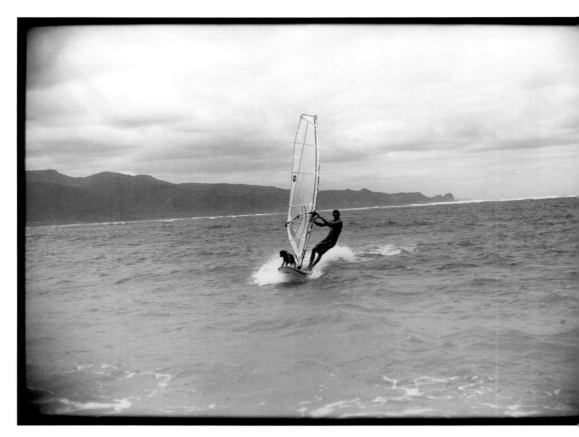

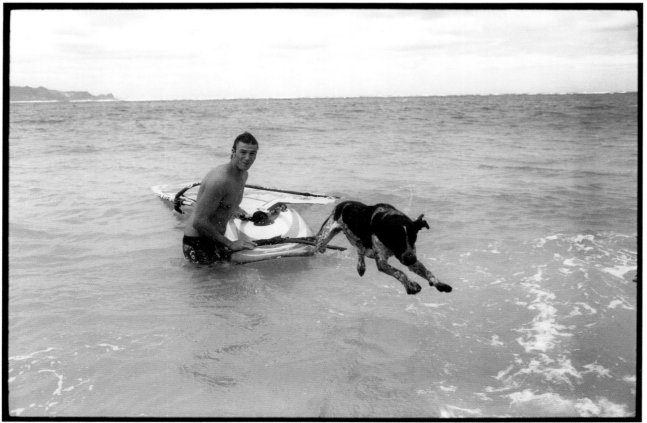

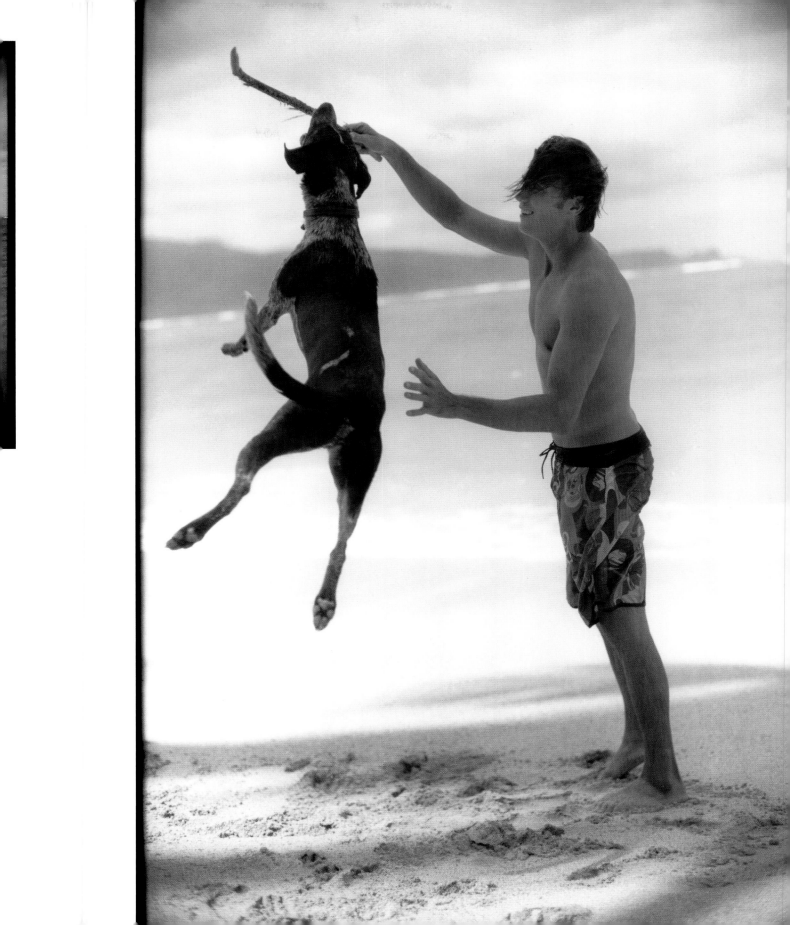

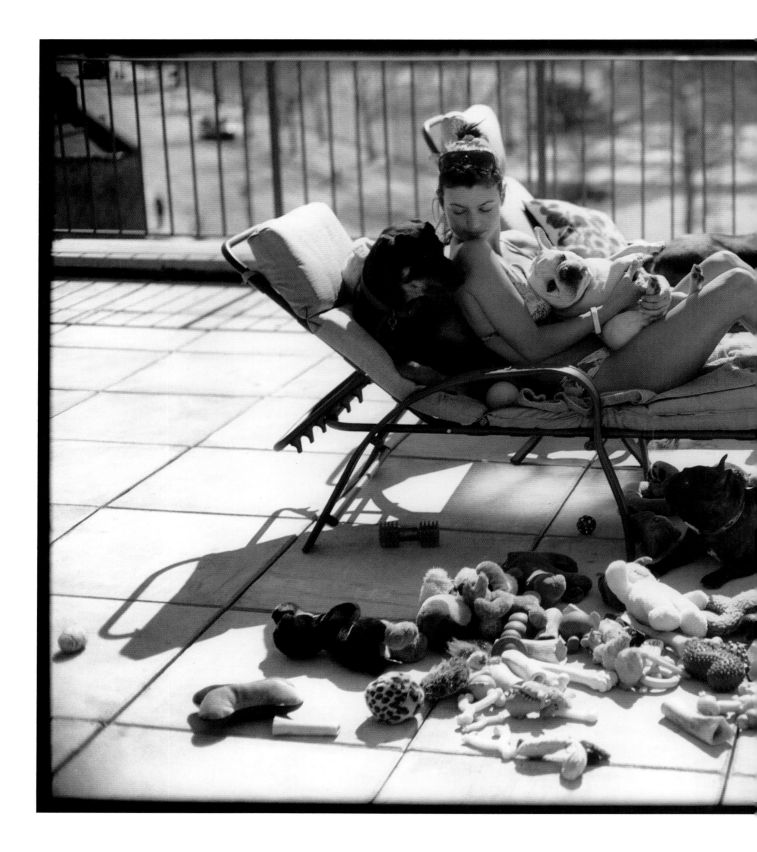

Michelle Ray Smith, actress

"Every day my dogs find something to celebrate. Whether it's as simple as finding that last piece of popcorn under the couch or barking at a would-be intruder, my dogs live their lives with passion and excitement. That is the lesson and gift that they have given me."

Gary Dell'Abate,

Baba Booey of *The Howard Stern Show*

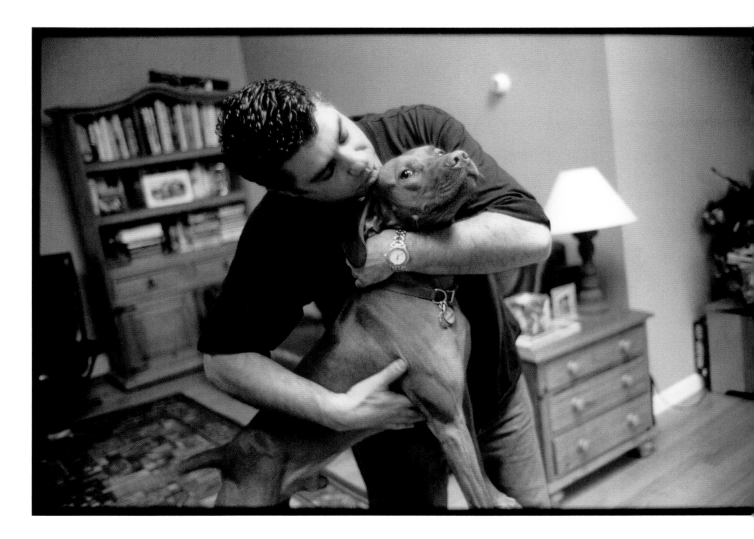

*"Murphy has helped our family by showing us
so much love and affection; we get along better
because of him. Plus, every day when I get home
he's excited to see me—some days I need that."*

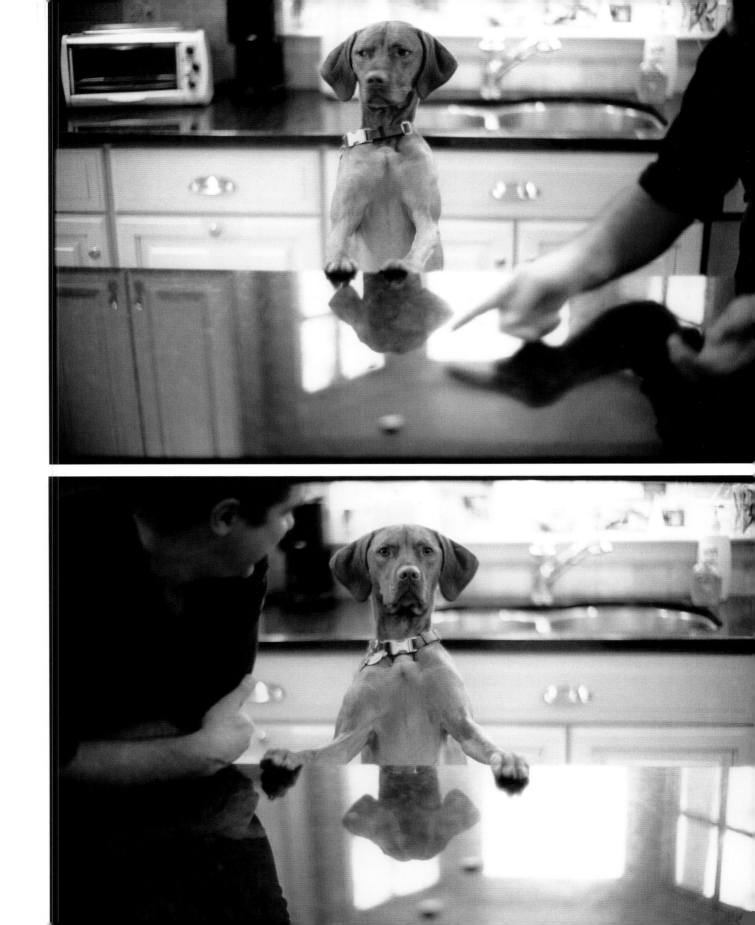

Tucker Carlson,
political news correspondent and commentator

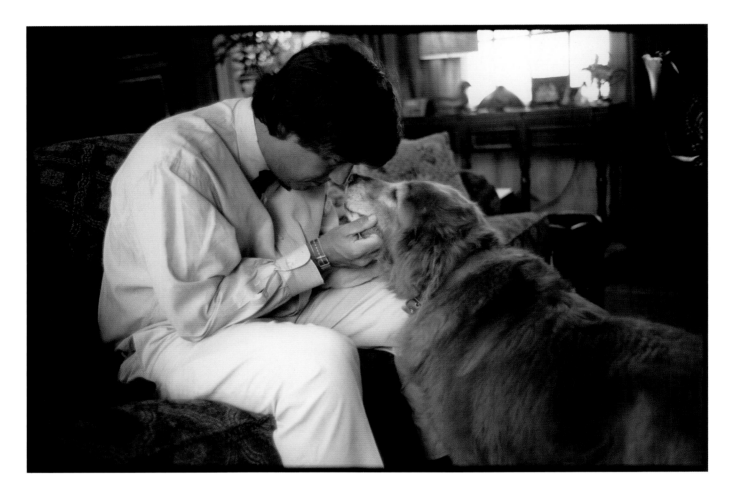

*"My dogs help me sleep. My wife and I never go to bed without
a spaniel between us, and I always wake up refreshed."*

Tucker Carlson
?
Agnes

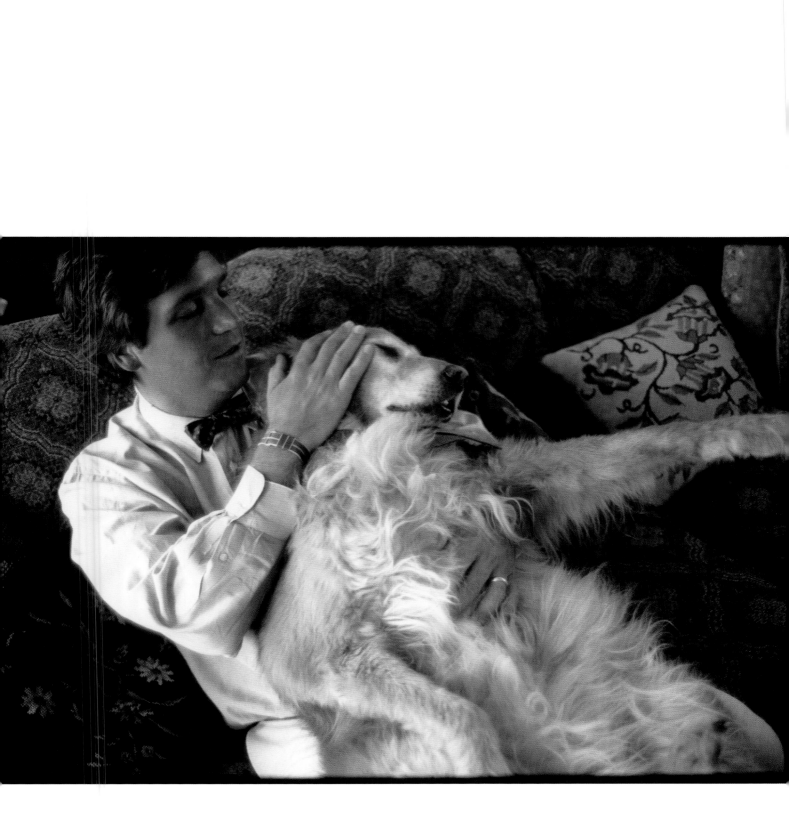

Shane and Sia Barbi,

aka the Barbi Twins,

models, authors, and animal activists

*"Most search the world for a perfect dog, but we should try
to create the perfect world for the imperfect dog and always
remember that we don't save dogs, they save us."*

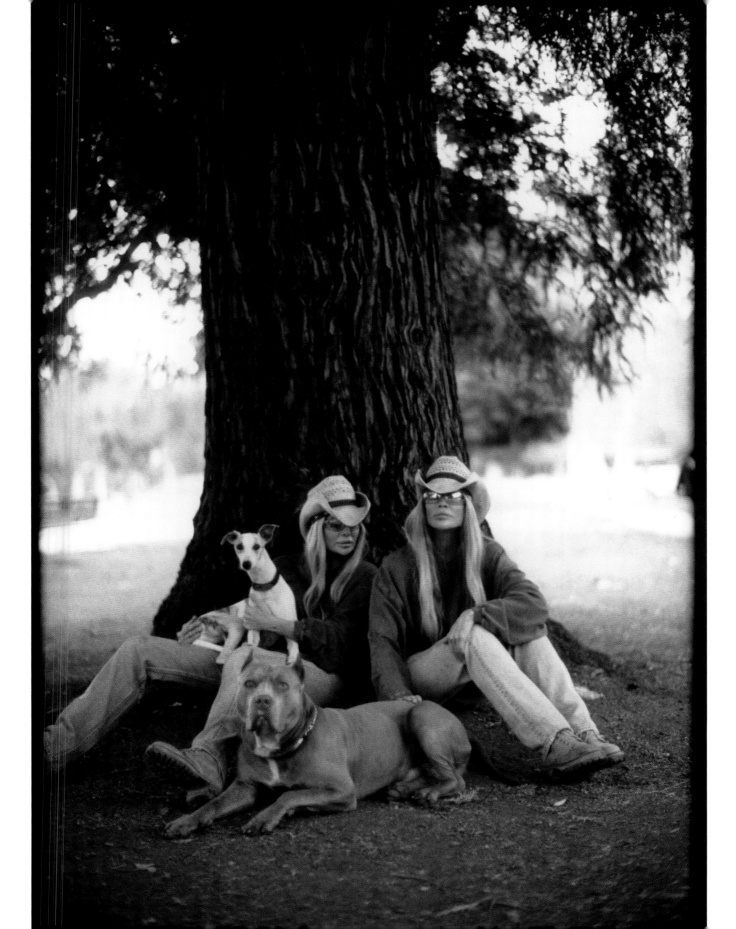

David Cooley,
owner of The Abbey

Thanks for a great photo day! Great Cause!
XO
David Cooley
Rio
CoCo

"No matter how difficult the day has been, just seeing that
my dogs want to make me happy instantly makes it better."

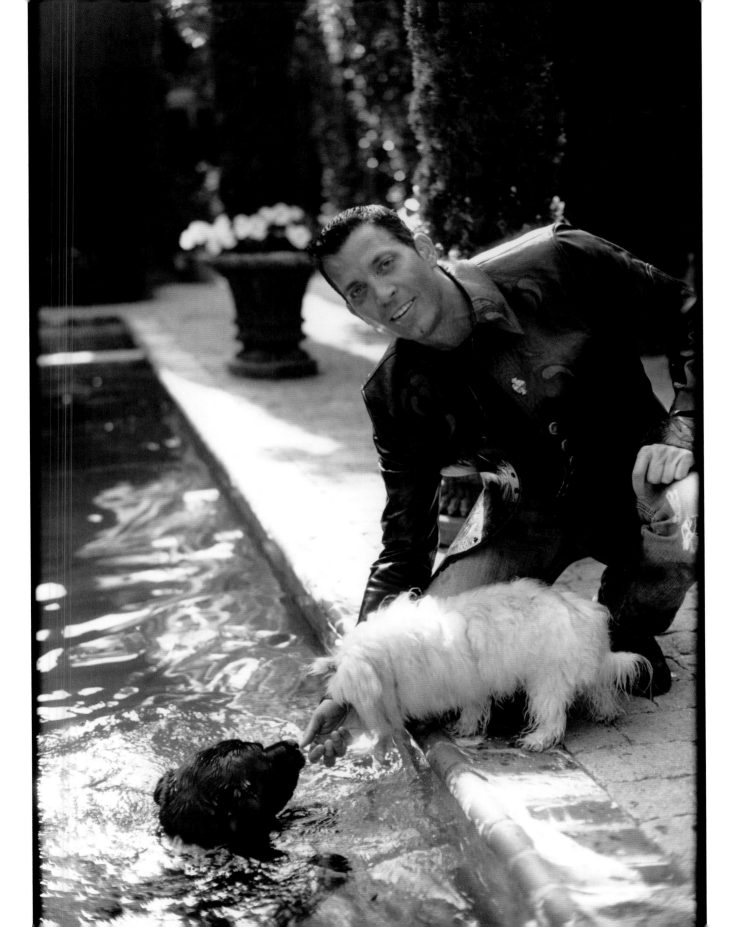

Eric Szmanda, actor

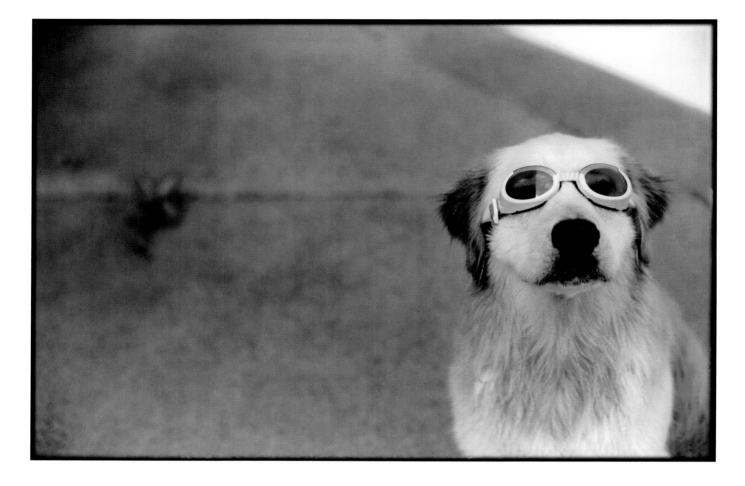

"Dax has helped me relax."

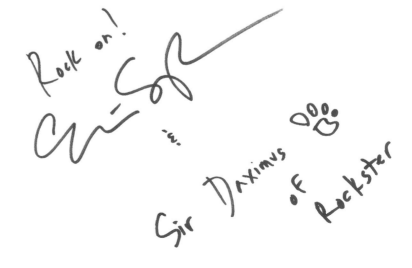

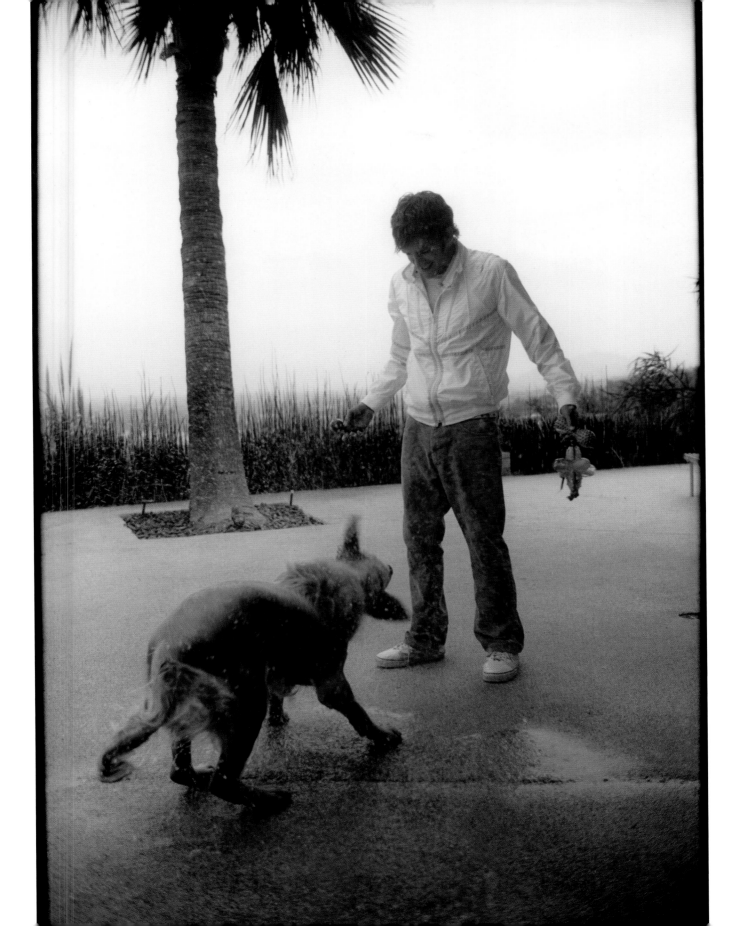

Patton Oswalt, actor, writer, and comedian

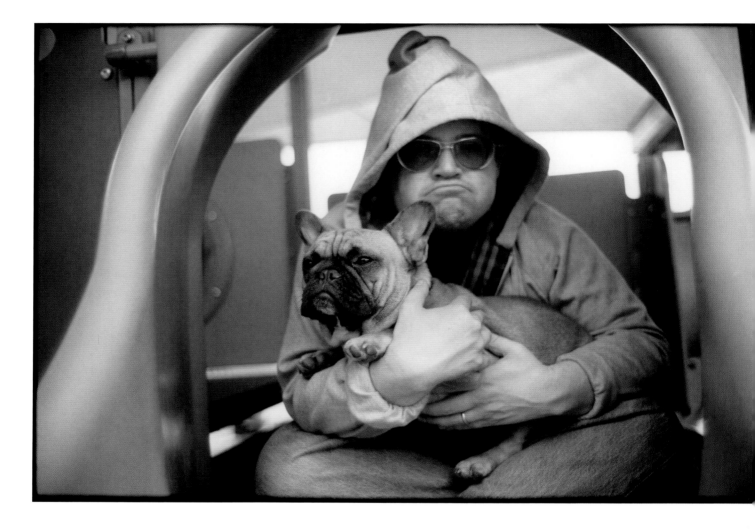

Your dog doesn't know you've been working all day to make that car payment; he just knows you're home and it's his turn for a walk and a belly rub. Don't let him down!
—The Humane Society of New York

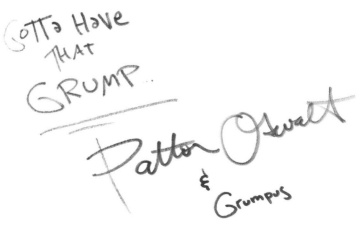

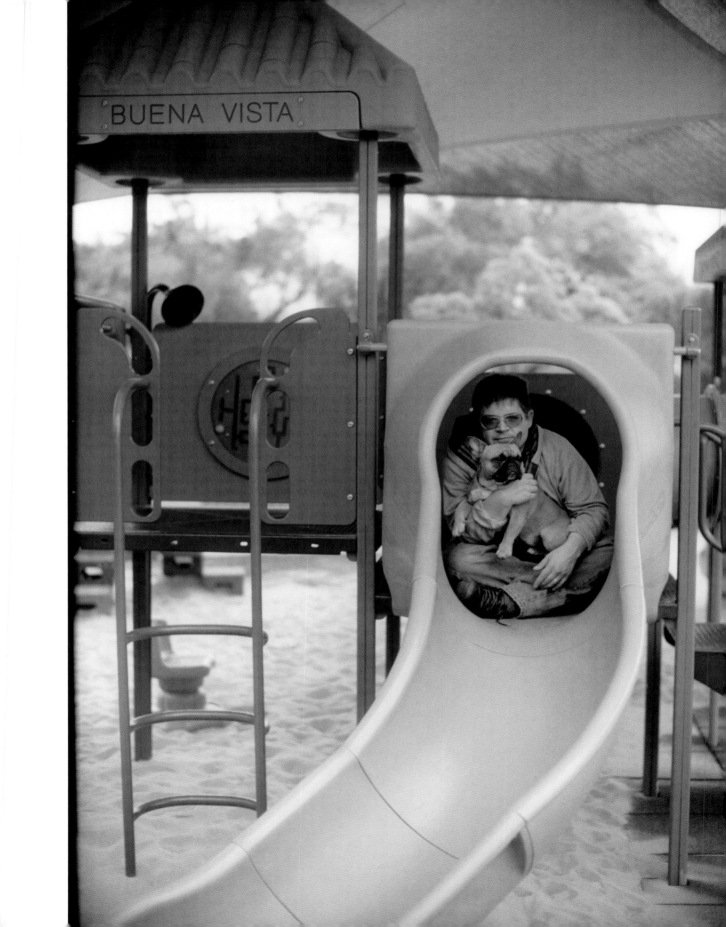

Andrew Firestone, former *Bachelor* and co-owner of Curtis Winery

Spaying or neutering dogs
helps them live longer and
controls pet overpopulation.
There's no downside.
—THE HUMANE SOCIETY OF NEW YORK

Woof!

Paul Bond, owner of the Paul Bond Boots Company

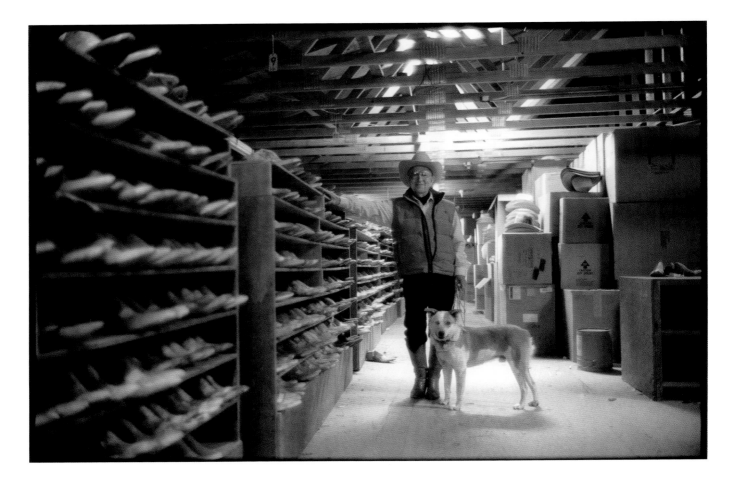

Paul Bond

Even simple things like leashes and
food bowls are probably on your
local shelter's wish list, so give
them a call to see how you can help.
—THE HUMANE SOCIETY OF NEW YORK

Dr. Nicholas Perricone,
clinical and research dermatologist, author

PEANUT

N V Perricone M.D.

Nothing a store has to sell is more valuable
than your dog. If he can't come inside,
never tie him up and leave him out front—
even for a minute—where he can be stolen.
Take your dog home and go shopping later.
—THE HUMANE SOCIETY OF NEW YORK

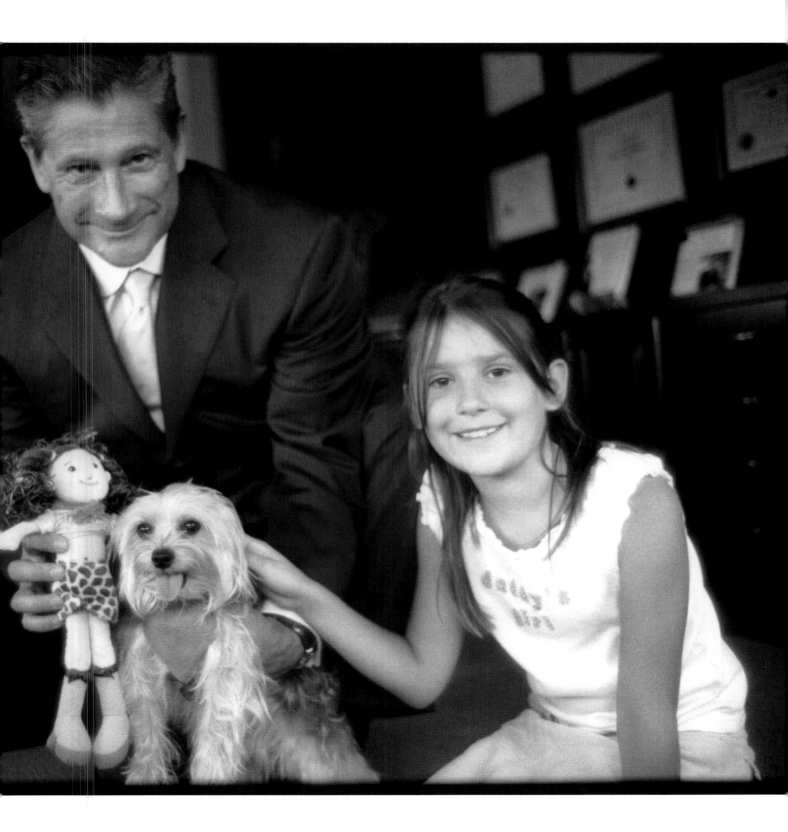

Dan Stoloff, cinematographer

"King taught me patience and kindness,
and has kept me grounded through
the simple concepts of unconditional
love, pride, companionship, and the
responsibility of caring for my best friend."

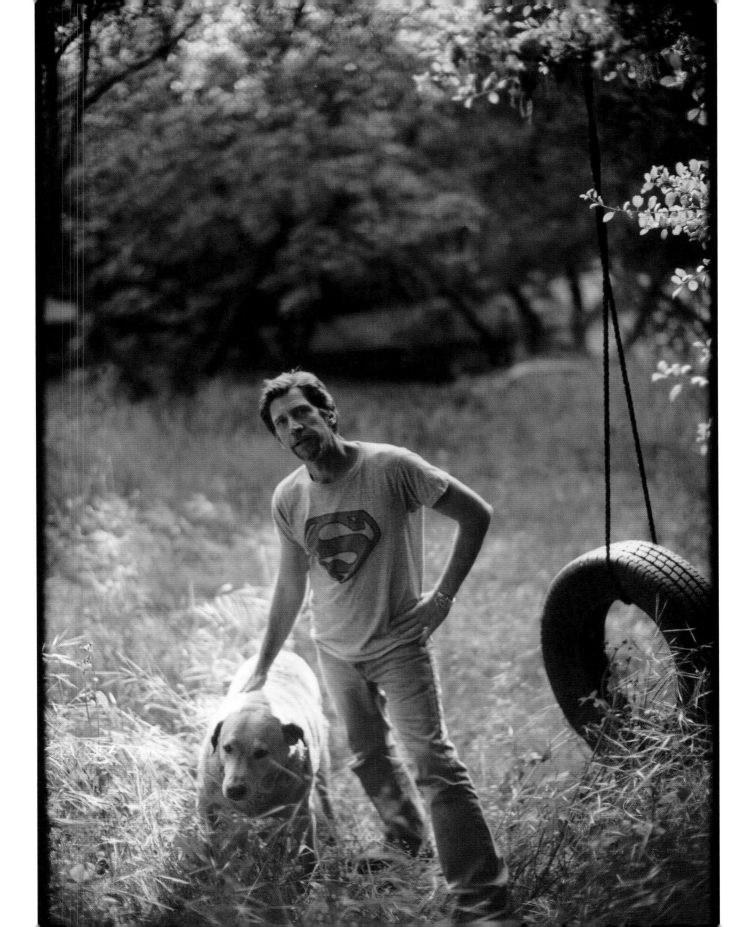

Mark Derwin, actor

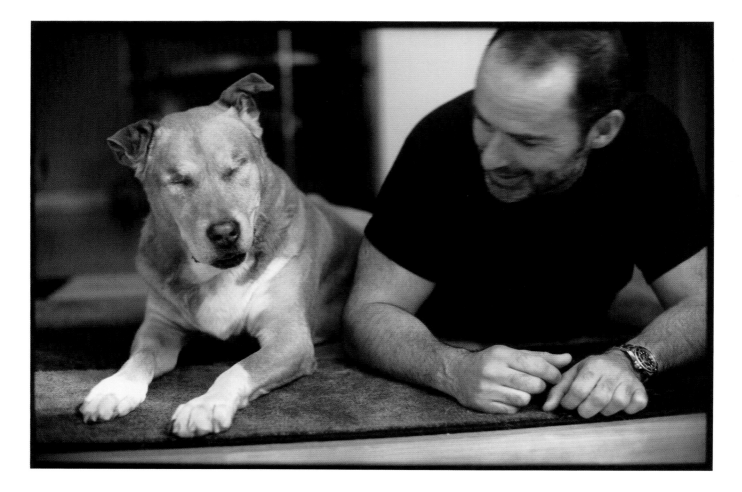

"My dog taught me to smell my food before eating it."

Mark Derwin & Jim the Dog.

Vanessa Carlton, singer and songwriter

"*Lord Victor is my constant companion. I used to let touring throw me into 'black hole mode' and never leave my hotel room, but Victor smells an adventure in every town, and now we walk through a new city every single day. He's a pretty witty fella to boot. Frankly, I can't imagine life without him.*"

Joe Bravo, jockey

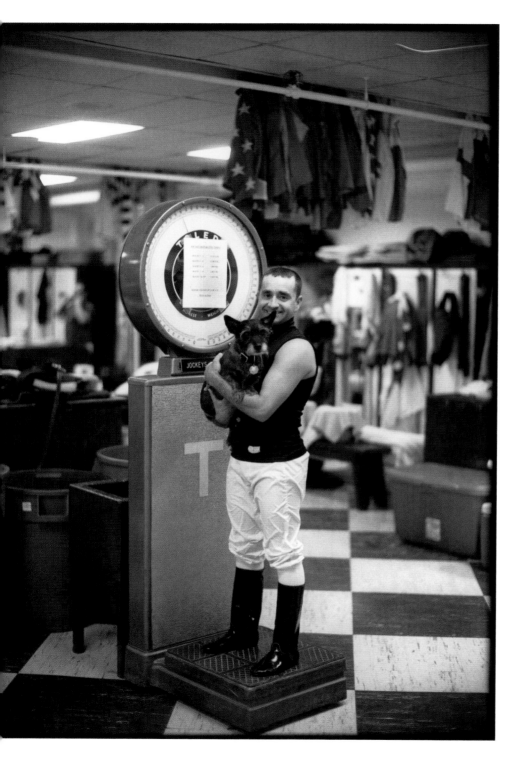

If your dog is a people-pleaser and knows basic obedience, consider therapy-dog certification. Then watch the joy he'll bring to those most in need of a friendly, furry "hello."

—THE HUMANE SOCIETY OF
NEW YORK

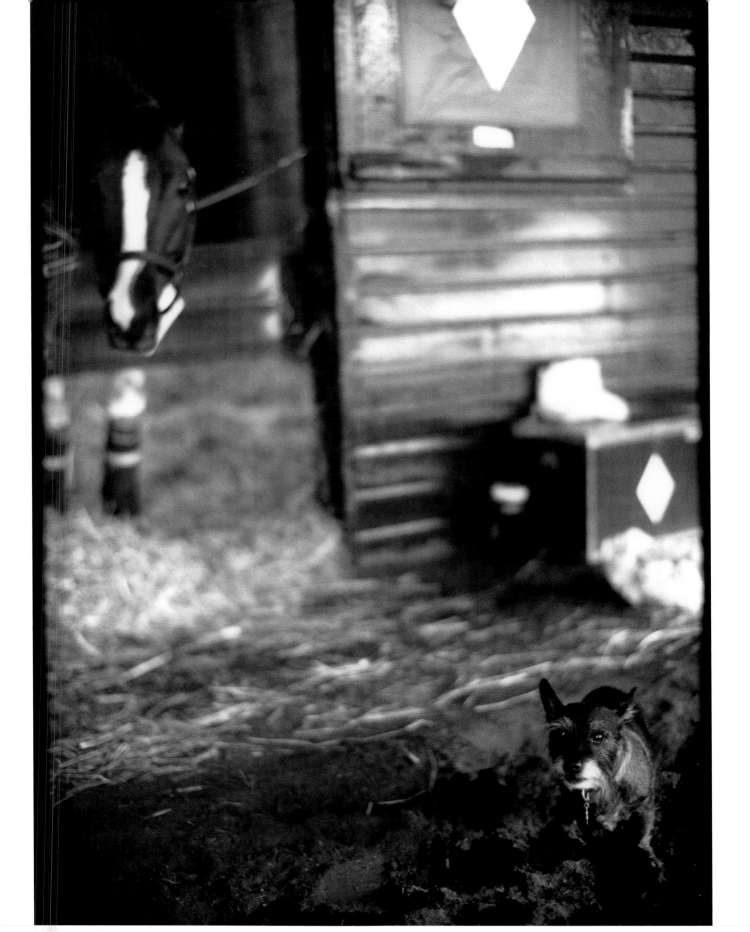

Fran Drescher, actress

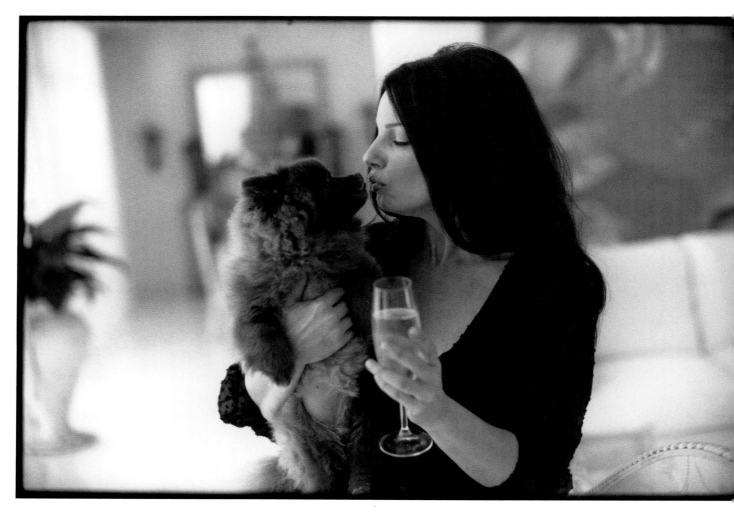

F & e Fran Drescher
&
Esther Drescher

Brian on behalf of all
animal lovers everywhere,
thank you & God Bless!
Fran E Drescher + Esther x

*"My dog Esther has taught me
that there is love after love."*

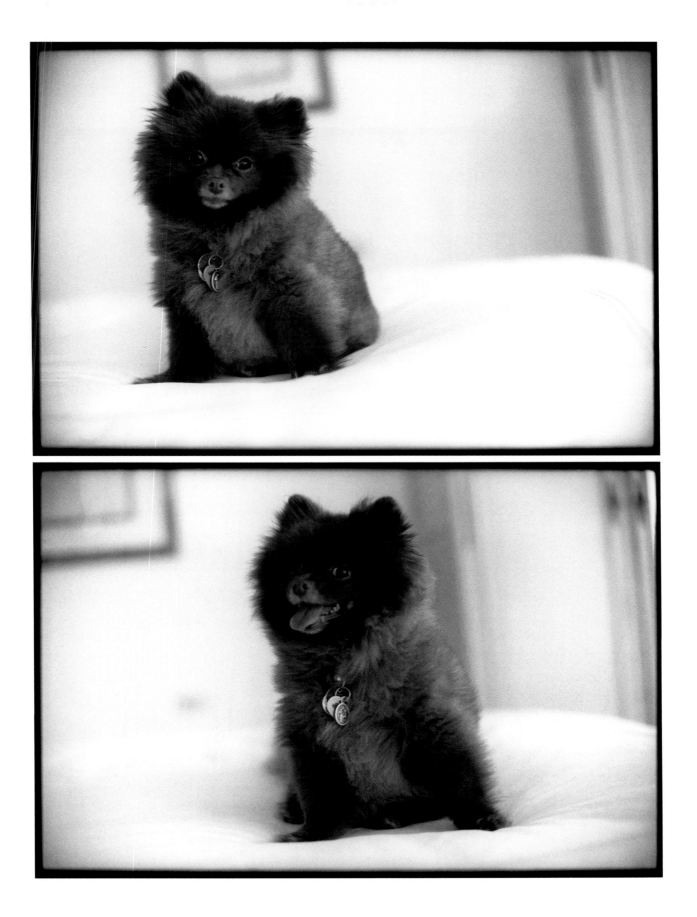

Jason Biggs, actor

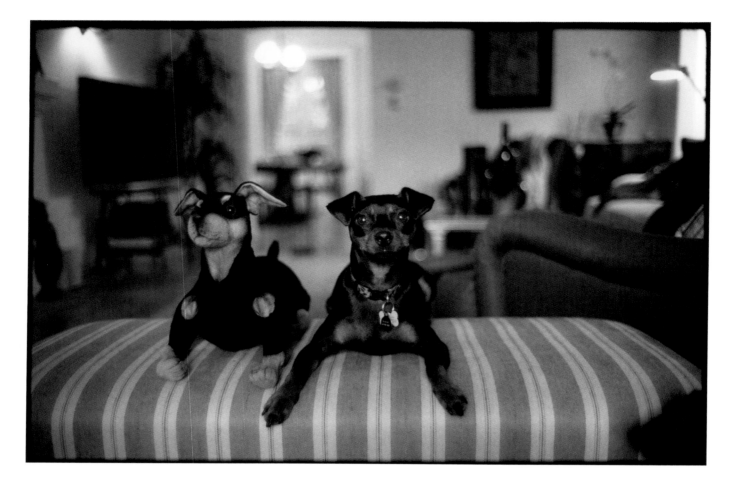

Edgar and Harry

"My dogs help me relax and never fail to put a smile on my face. They have saved me thousands of dollars in therapy and Zoloft."

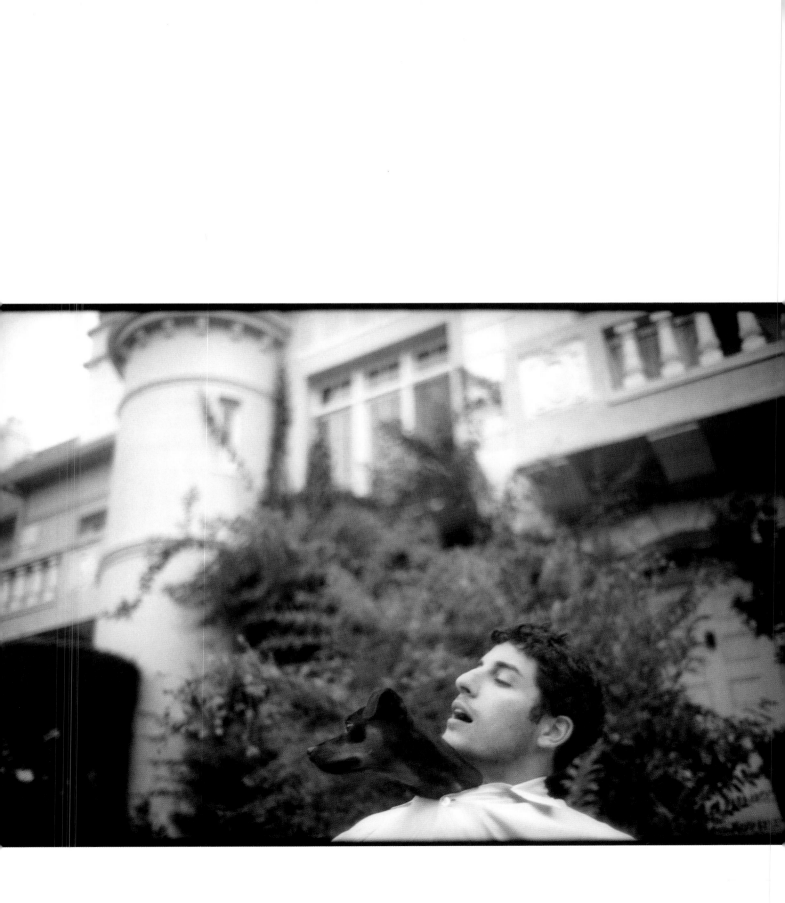

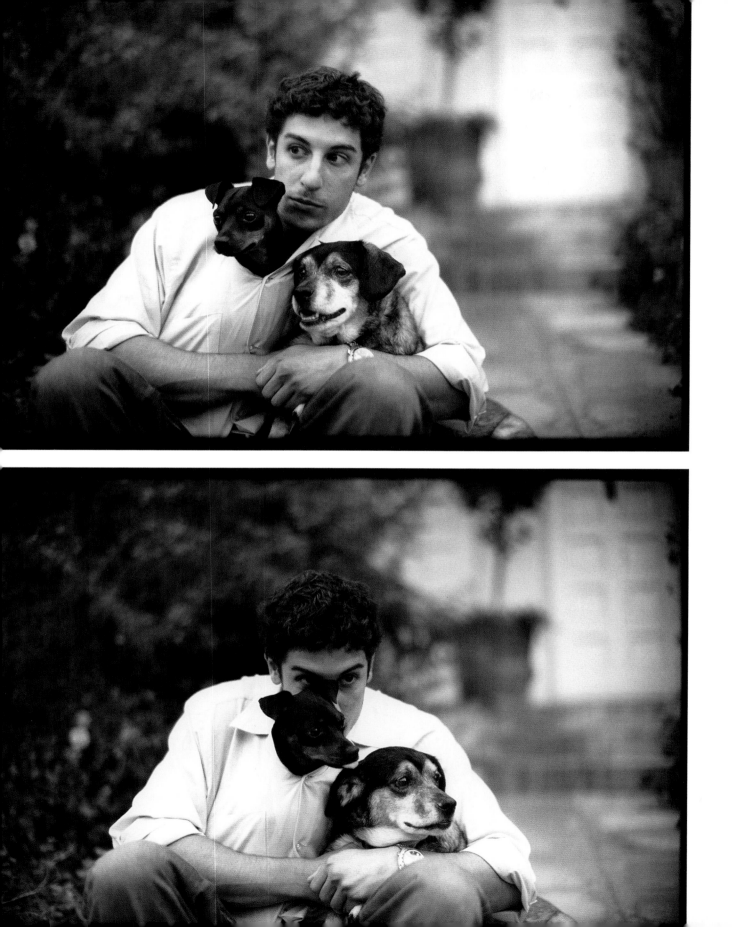

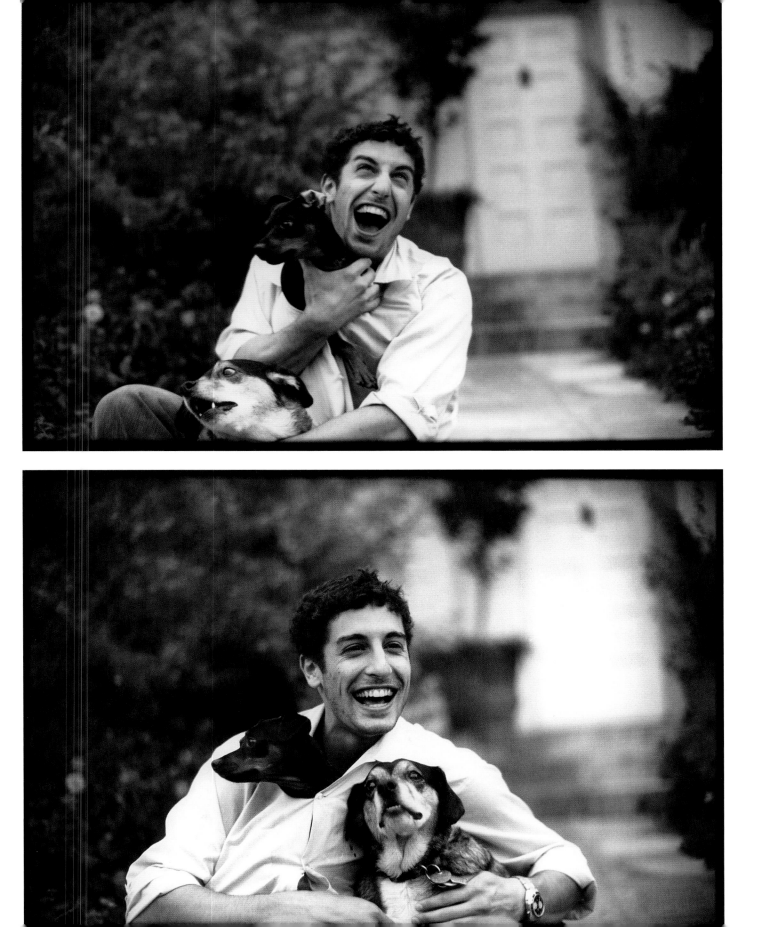

Kevin Smith, director

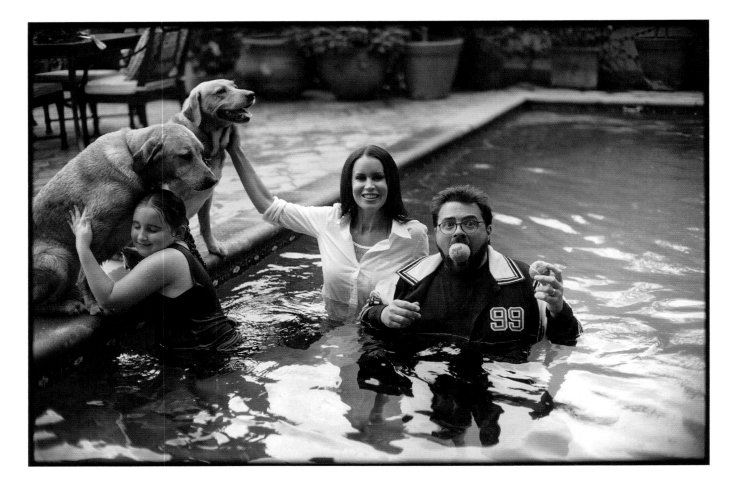

"The way our house was designed, you have to climb a minimum of one steep flight of stairs to let the dogs out—which means Scully and Mulder are responsible for the only form of cardio I do."

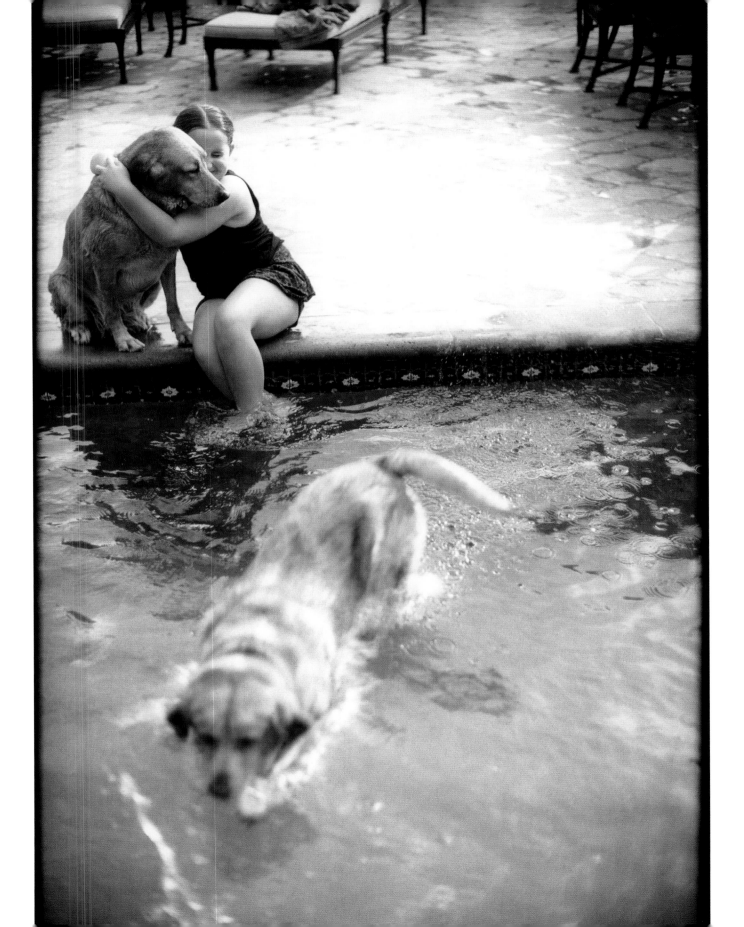

Jorja Fox, actress

Jira Fox

Ali Hessel Fox

Quit lighting up! Secondhand smoke is bad for your dog,
so kick the habit and help him light up your life for years to come.
—THE HUMANE SOCIETY OF NEW YORK

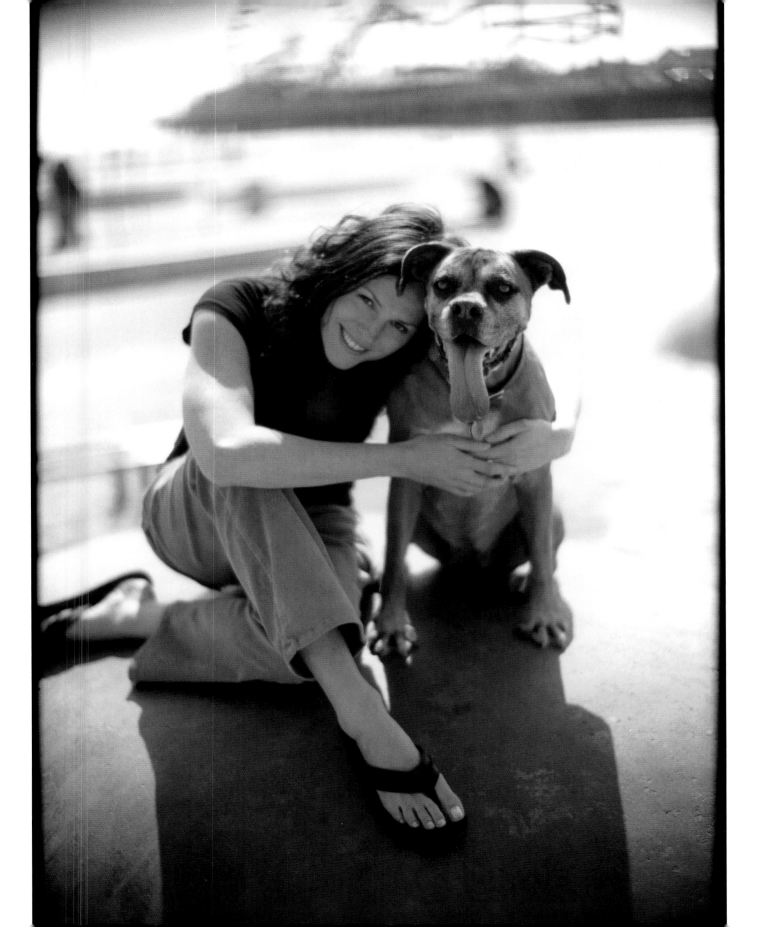

William Petersen, actor

Bruno —
my best friend
and my acting mate.

Peace,
William Petersen

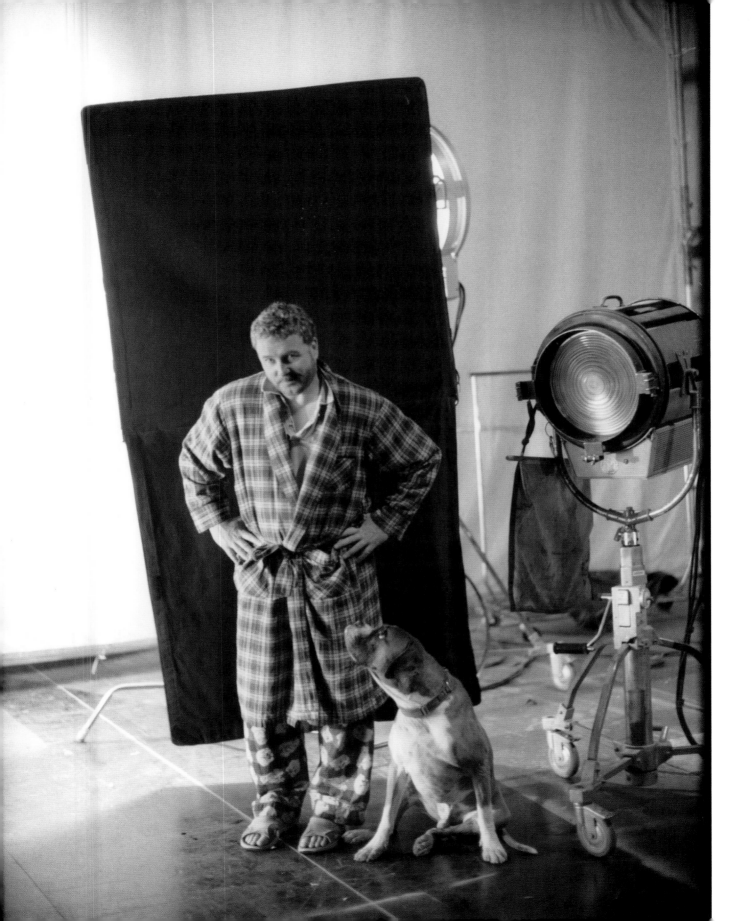

Marg Helgenberger, actress

Momo
(my special boy)

Marg Helgenberger [signature]

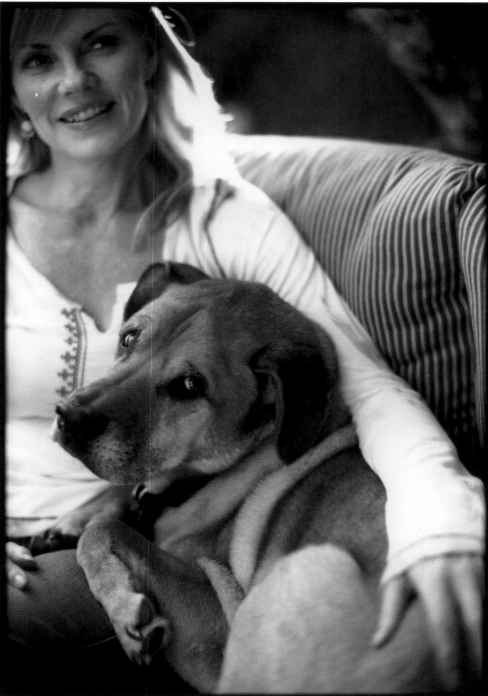

"*Momo was the most sensitive, noble creature I've ever known. Whenever I was blue, he comforted me.*"

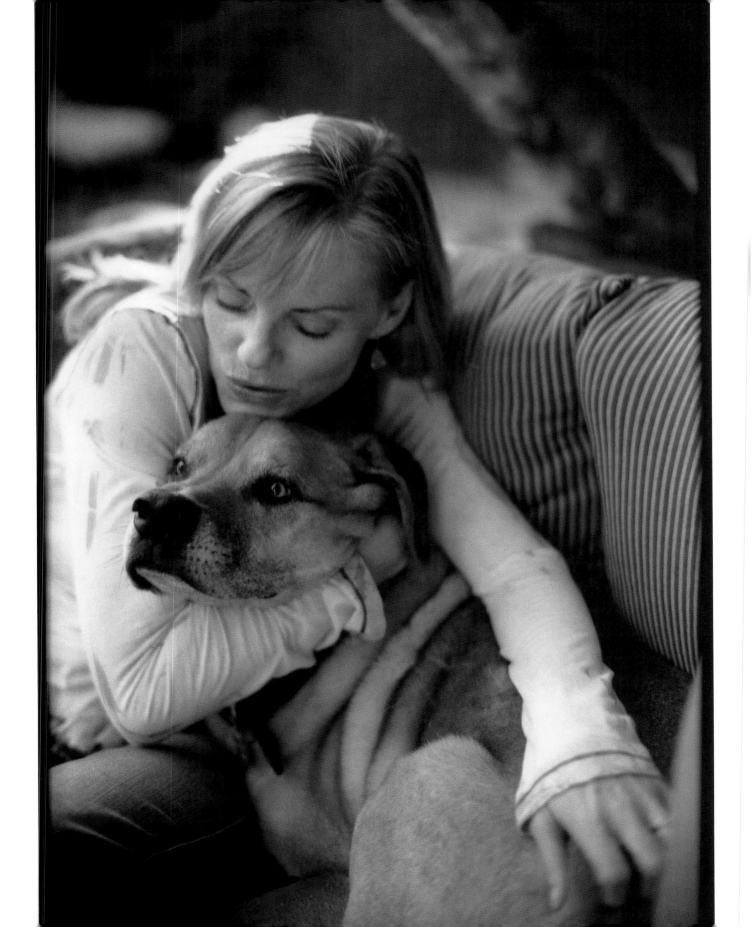

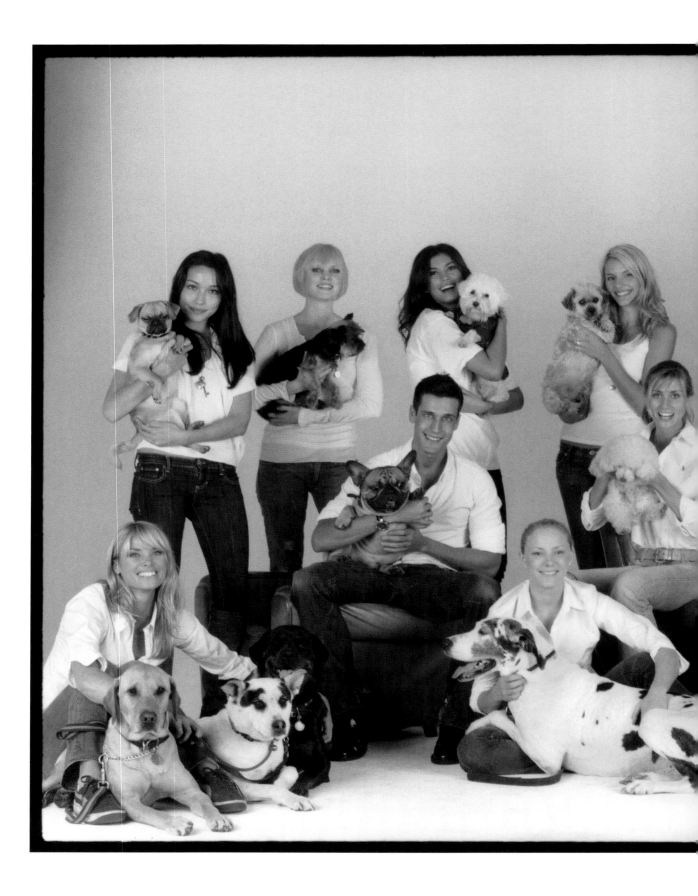

Models in New York City

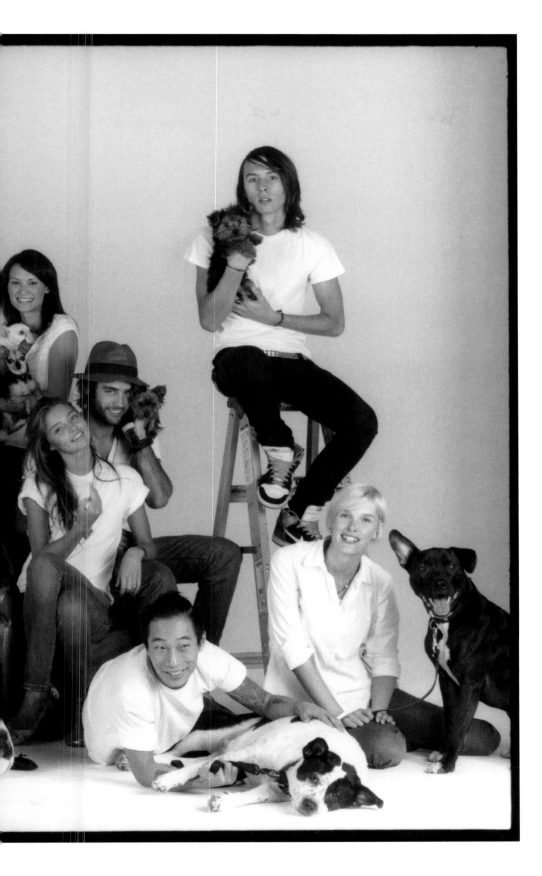

Prospective adopters
need expert guidance
to match them with
animals that will live
happily and safely
with their families.
Compatibility is
essential. Unless the
right home is chosen,
no one is helped.
—THE HUMANE SOCIETY OF
NEW YORK

Georgette Mosbacher, CEO of Borghese, author, and philanthropist, and **Lyn Paulsin,** sisters, director of public relations for Borghese, former model, and philanthropist

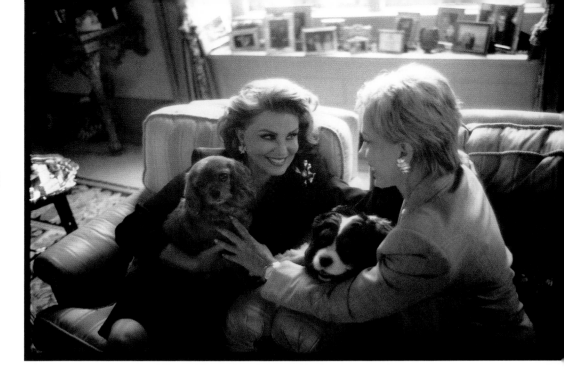

Eve
Georgette Mosbacher

Cosmo
Lyn Paul—

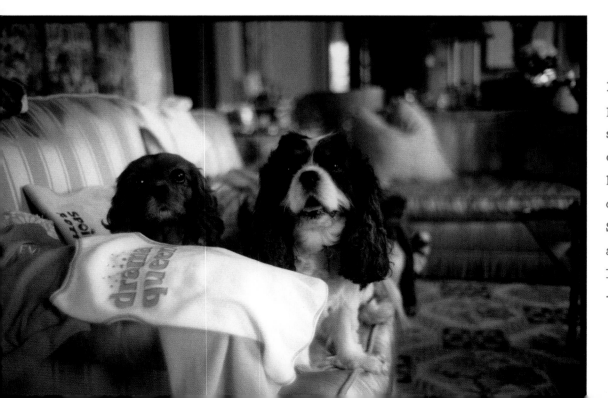

If your dog knocks people over when she greets them, consider taking her to a basic obedience class. She'll get manners, a diploma, and a lot more friends.
—THE HUMANE SOCIETY OF NEW YORK

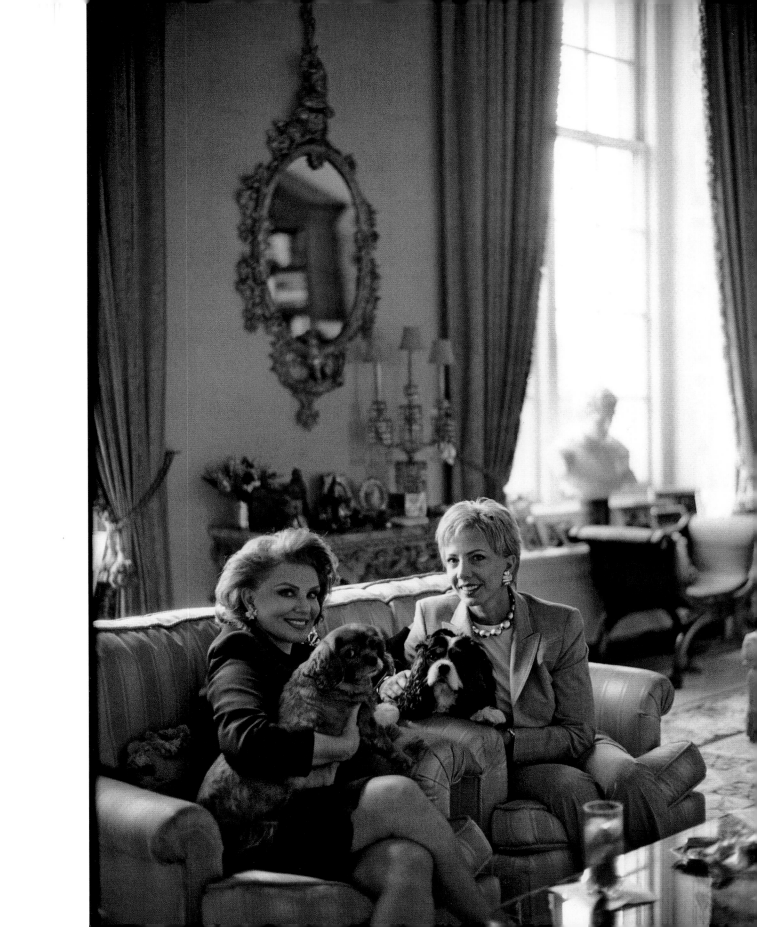

Steven Gambrel, interior designer, and **Chris Connor,** entrepreneur

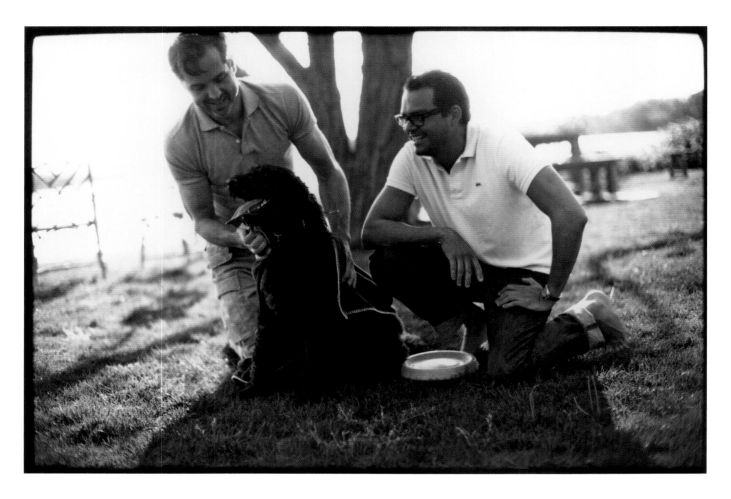

DASh, Sun, frisbee
and SAg HARboR make
the peRfect weekend!

ARgambrel
Chris Connor

*"Dash reminds me daily how pretty
a passing bird can be, how friendly
a passing stranger may be, and the
importance of daily downtime in the
park with a frisbee. Dogs keep us
grounded in the beauty of nature and
the simple things in life."*

Brooke Shields, actress

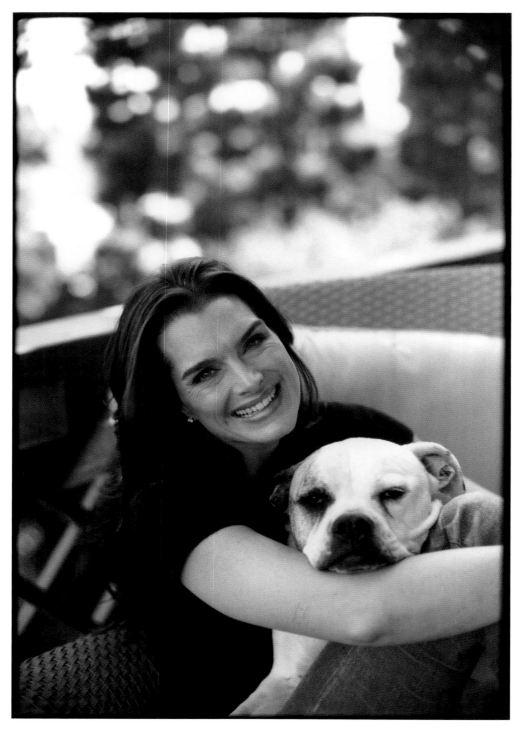

"Darla"
My first real baby!
I love you.
Brooke Shields

"Darla has been my quiet support during the worst times of my life."

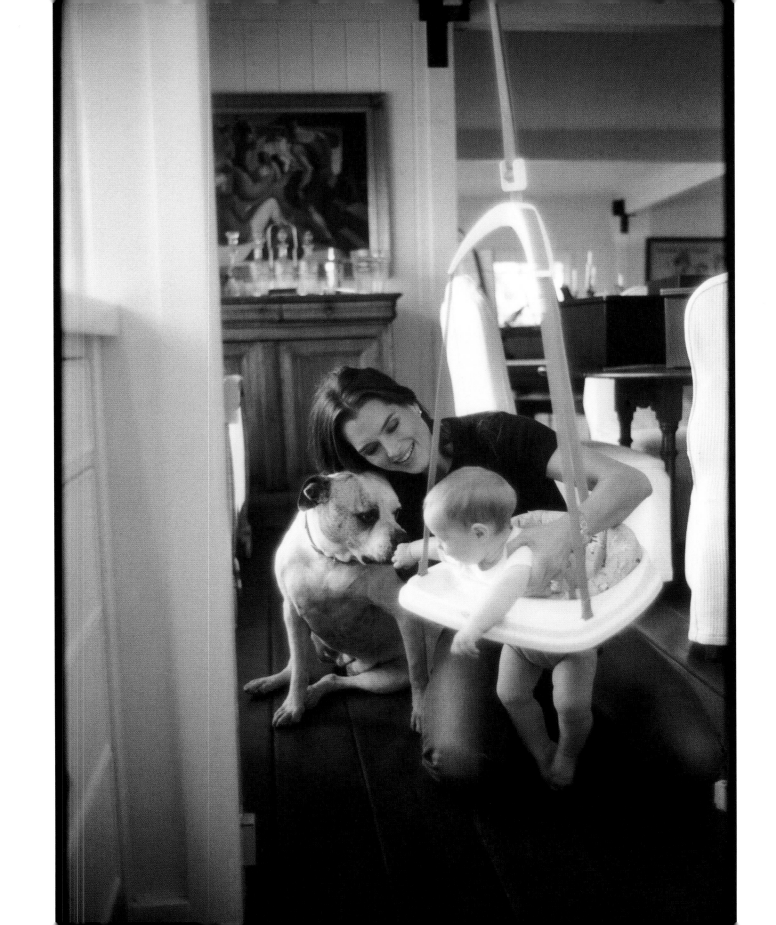

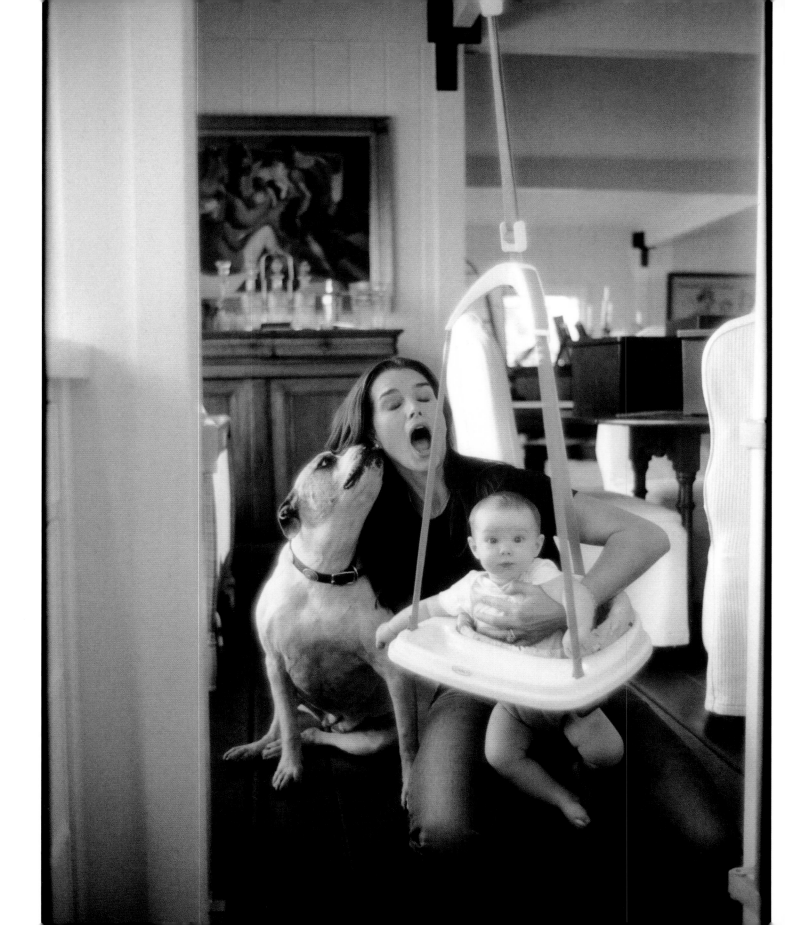

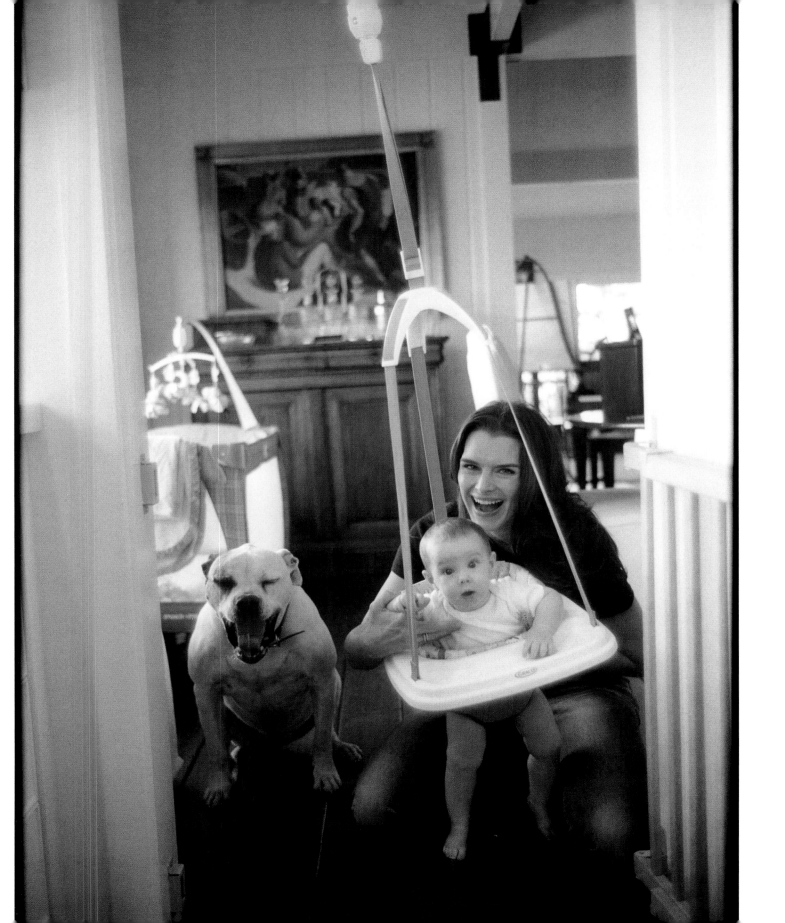

Reid Scott, actor

Bella & Dublin

"Bella's actually a really good cook and Dublin built
the bookshelves in my living room. (Dovetail joints!)
Kidding. They help me in so many ways—they warm
up my seat on the couch, they let me know when I have
mail, they make sure I get up before noon, they find my
keys . . . but mostly they're just good buddies. They've
helped me realize that in my next life I want to come
back as a happy, healthy, spoiled American dog."

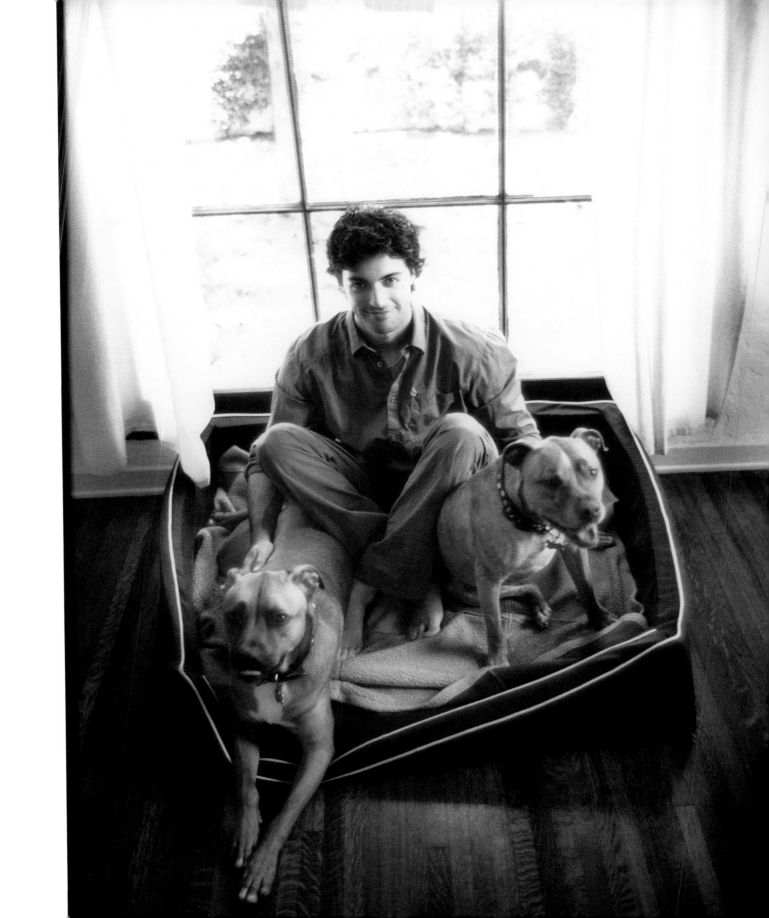

Cornelia Guest, actress, socialite, author

My Darling Angels
I Love you All Soooo
Much. You make life beautiful
XOXO
Cornelia Guest

"My dogs make the world a more beautiful place. Every moment spent with them is a lesson in love and gratitude. I am a very lucky girl!"

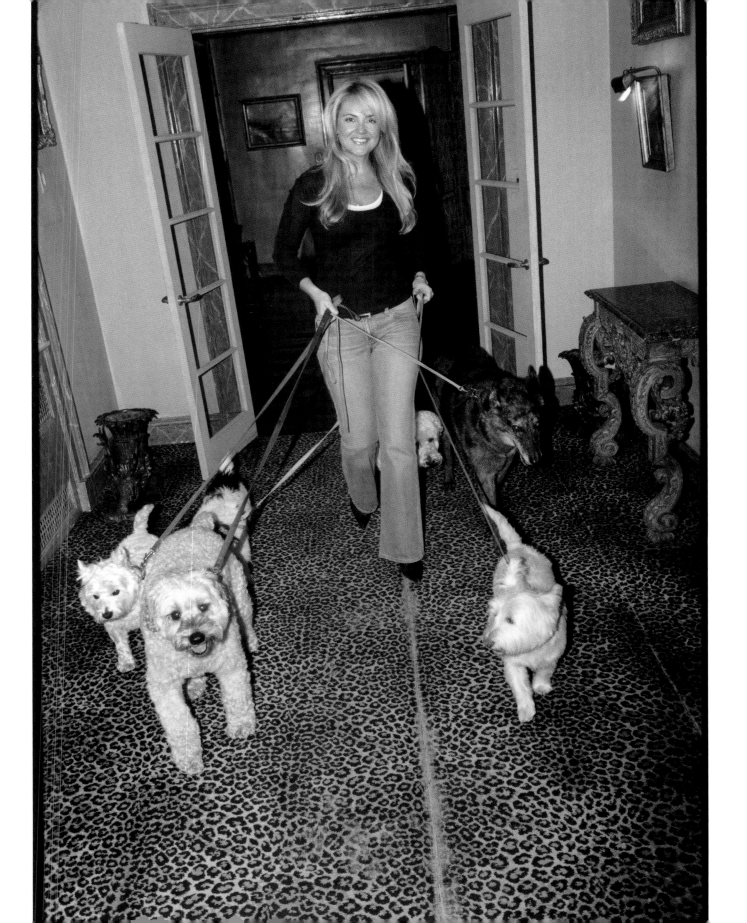

Aida Turturro, actress

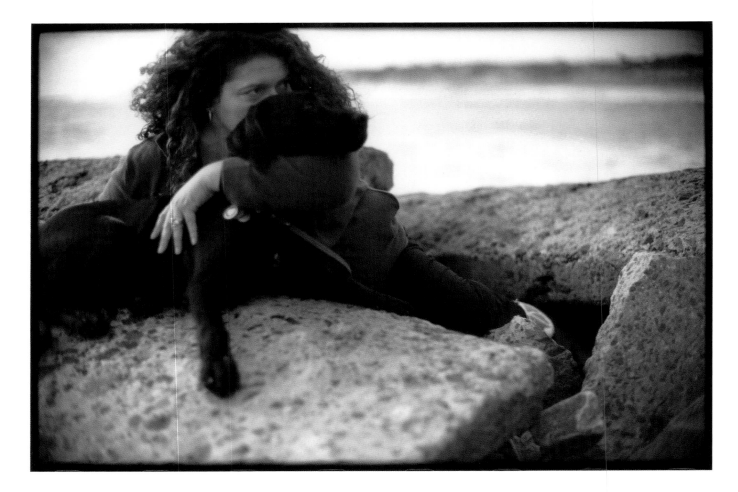

*"I never knew one soul could
give you so much love."*

Dearest Brian—
Thanks for a beautiful
day on the beach with
my bud.!

♡

"BUDDY"

Aida Turturro

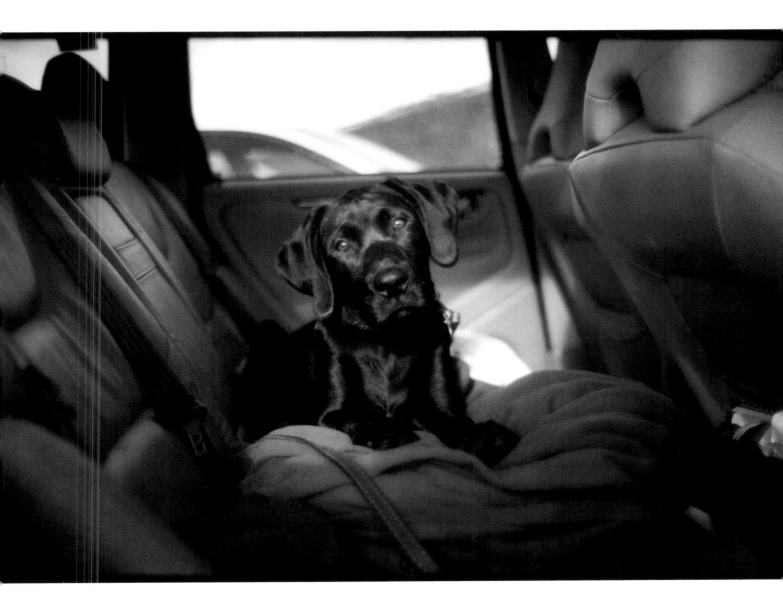

Edie Falco, actress

Edie Falco
Marley

When the mercury climbs, remember to provide your dog with plenty of fresh water and limit his time in the sun. Dogs can get sunburned, and it's up to you to protect them.
—The Humane Society of New York

Niki Taylor, model and TV personality, and
Burney Lamar, NASCAR driver

Ace, Jesse, Kaia,
Burney, Niki & cooper...

Road Dogs

Niki
Taylor

3·14·07

*"After traveling—which we do often—
our animals always give us the
perfect welcome when we get home."*

**Much Love Animal Rescue's
Bow Wow WOW event**

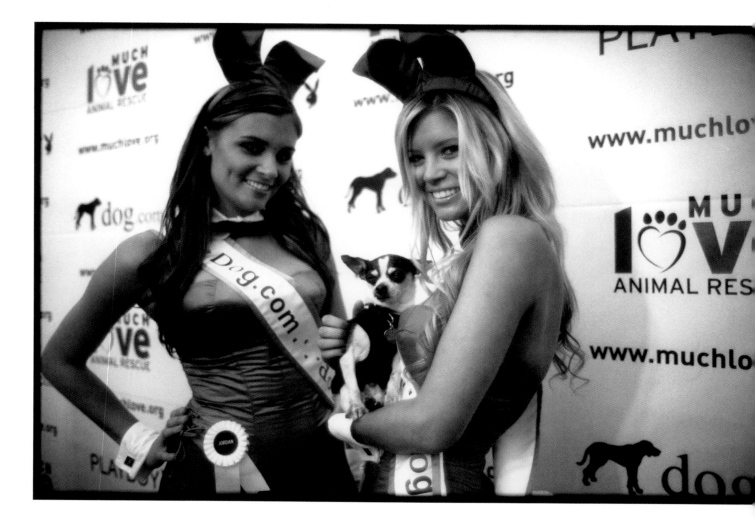

Four million animals are
euthanized each year in the
United States . . .

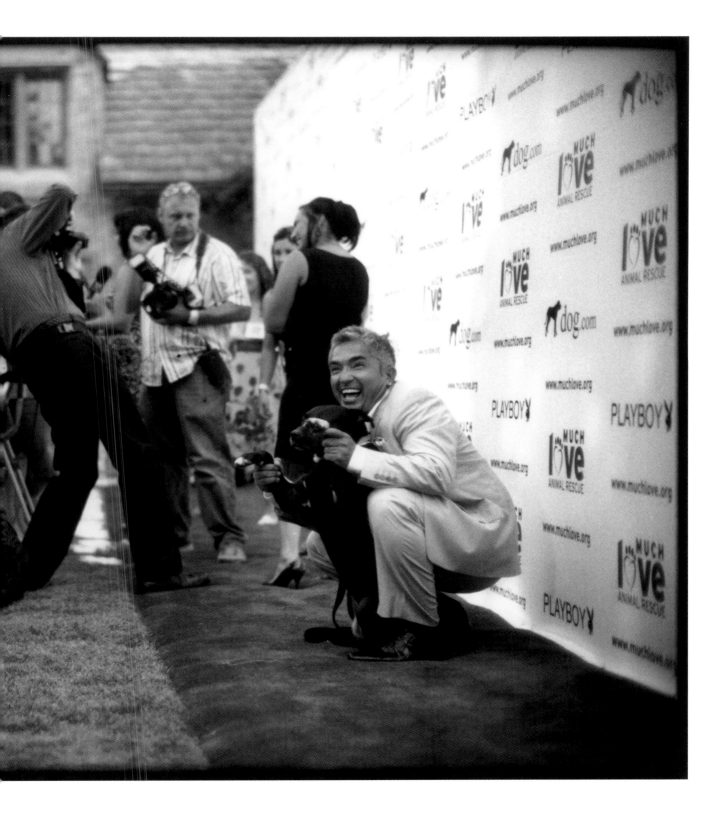

. . . that is 300,000 a month . . .

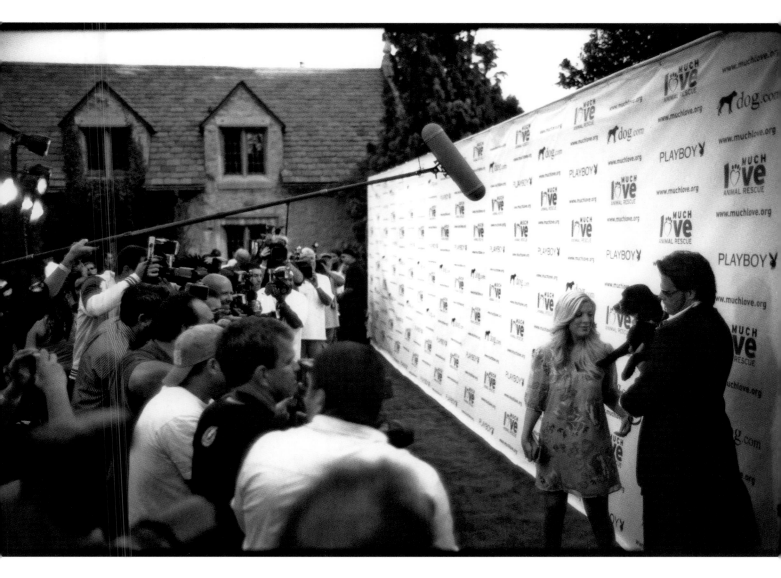

. . . and over 11,000 each day.

—Much Love Animal Rescue

Ed Burns, actor and director

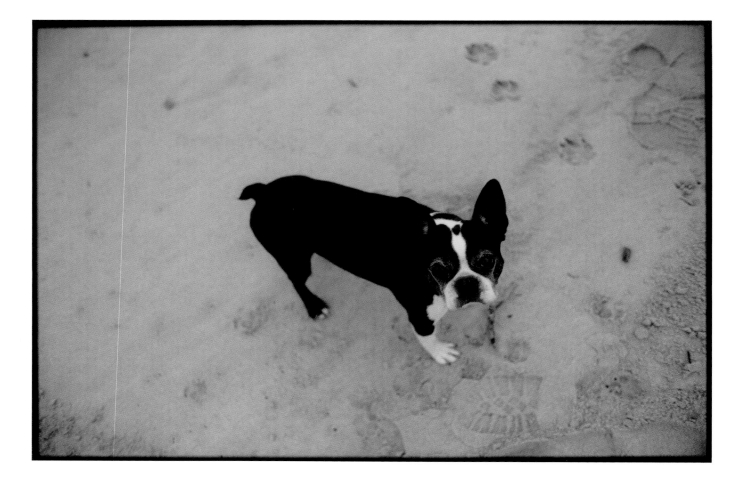

"The Mick helps me keep my feet clean."

B-NICE,

"THE MICK" AND I

HAD A FINE TIME.

ALL GOOD STUFF!

Ed Burns

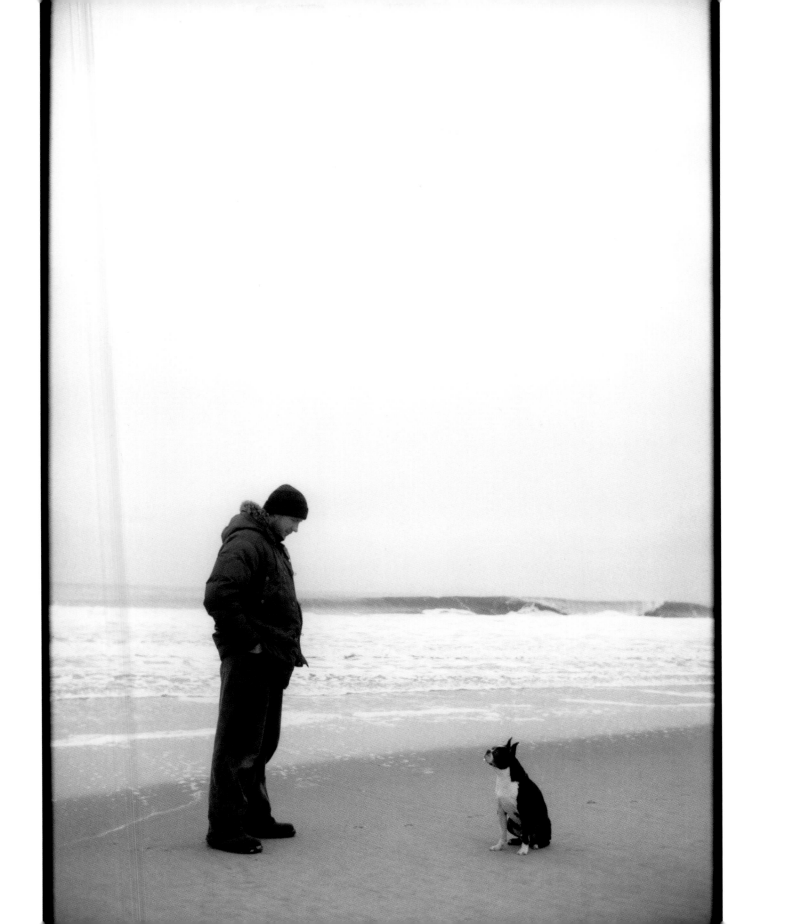

Rick Rubin, record producer, and **Amanda Santos,** model

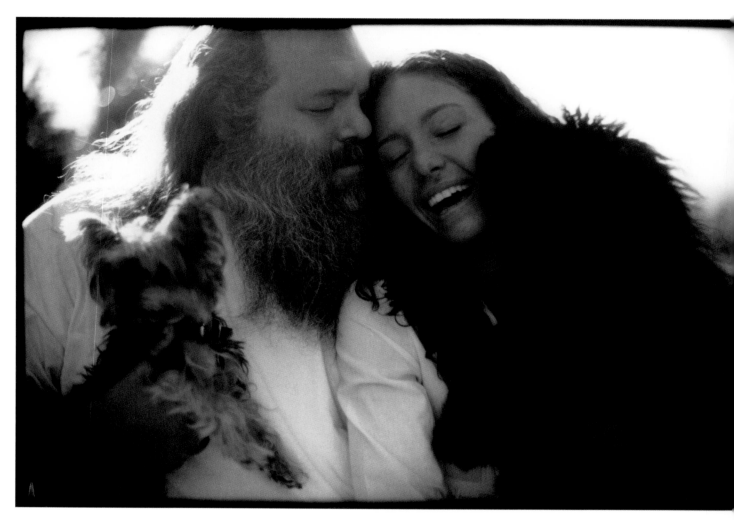

Henry
Cielo
Amanda
+
Rick
House
of
Love
Malibu, CA.

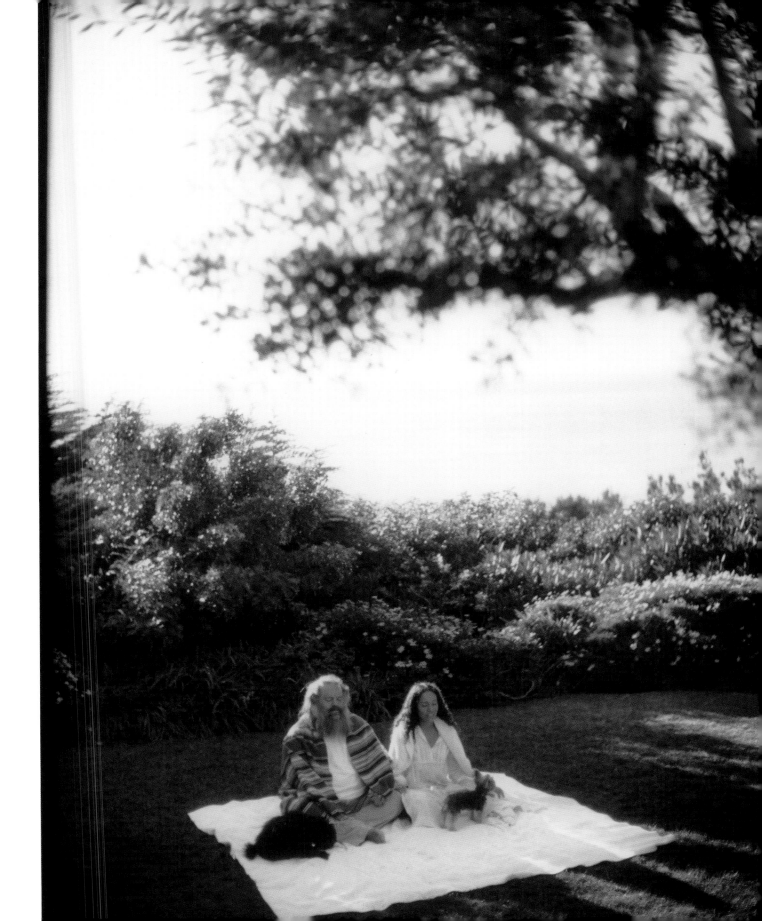

Ayako, makeup artist

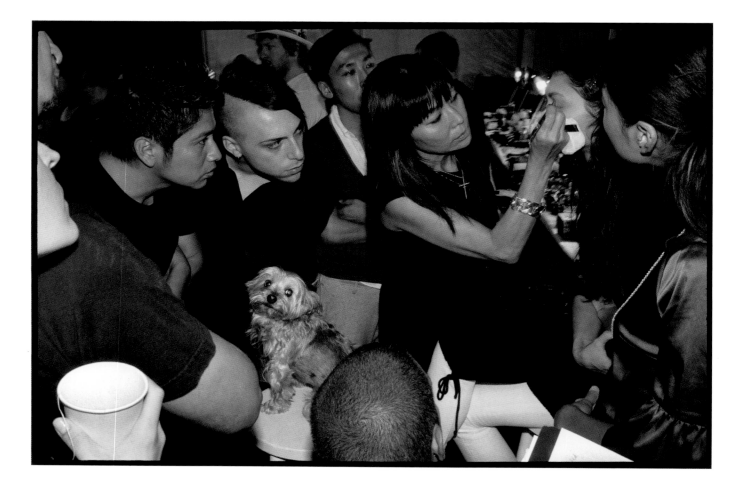

*"Jin Jin makes me smile whenever I'm
down—without saying anything, just by
being there. In addition, he's a cancer
survivor, and watching him recover
taught me how to be strong."*

I can't live without jin jin ♥.

ayako
9/9/07

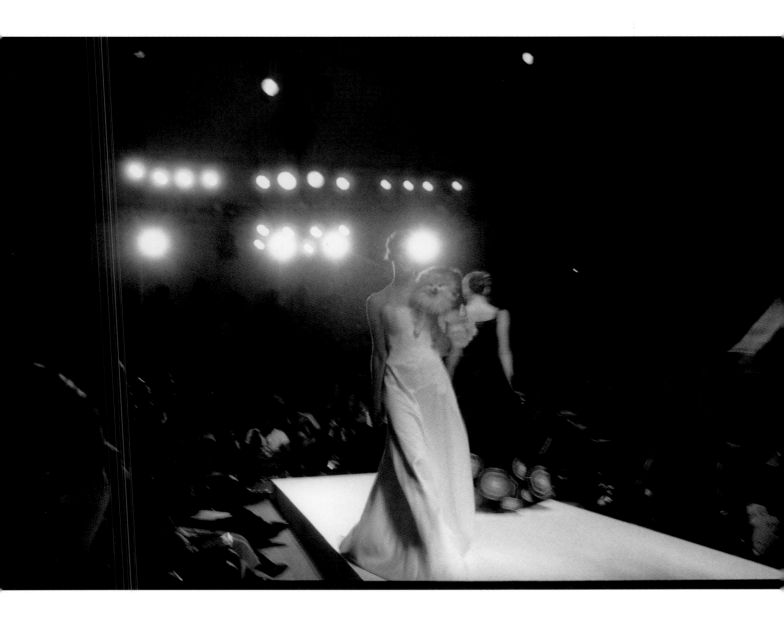

Mickey Rourke, actor

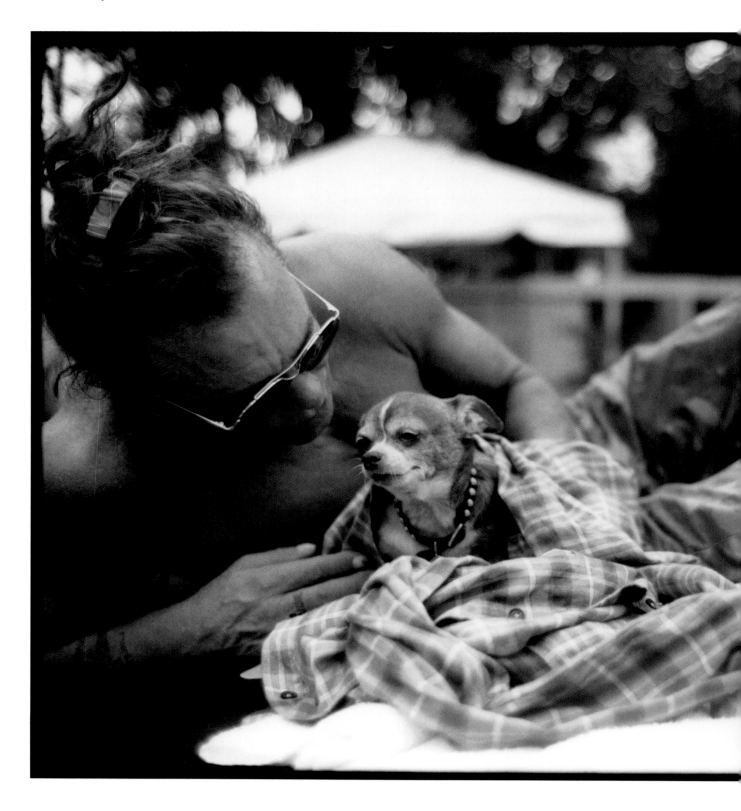

"Sometimes when a man's alone, that's all you got is your dog. And they've meant the world to me." (From Rourke's acceptance speech for his Golden Globe for Best Actor for his work in *The Wrestler*)

Bear Jack
Angel. Mick Row
Loki. Jesus. Esmerelda
Raphaill. Monkey.
Bella Cocka.
Chocko Domingo
Kiby baby.
Langra Garrett.
Romey.

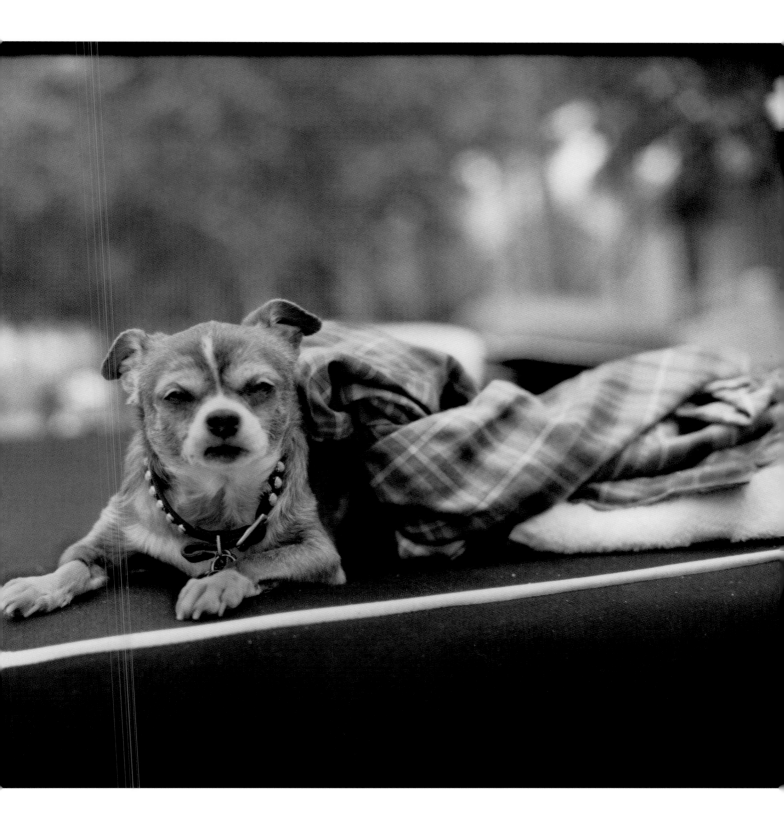

Debi Mazar, actress

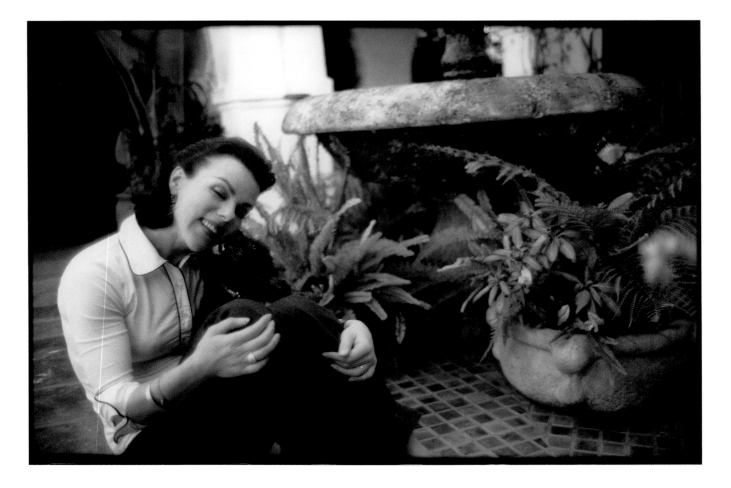

"Dolores prepared me for motherhood! My faithful companion for ten years, before my children came into this world, she taught me patience and responsibility. Dolores is now sixteen years old, a 'senior,' and has prepared me for taking care of my eighty-eight-year-old grandmother—they have similar health issues! She is my last/only lap dog. No other dog will take her place."

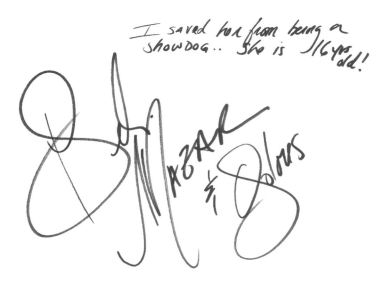

I saved her from being a SHOW DOG.. She is 16 yrs old!

Debi Mazar & Dolores

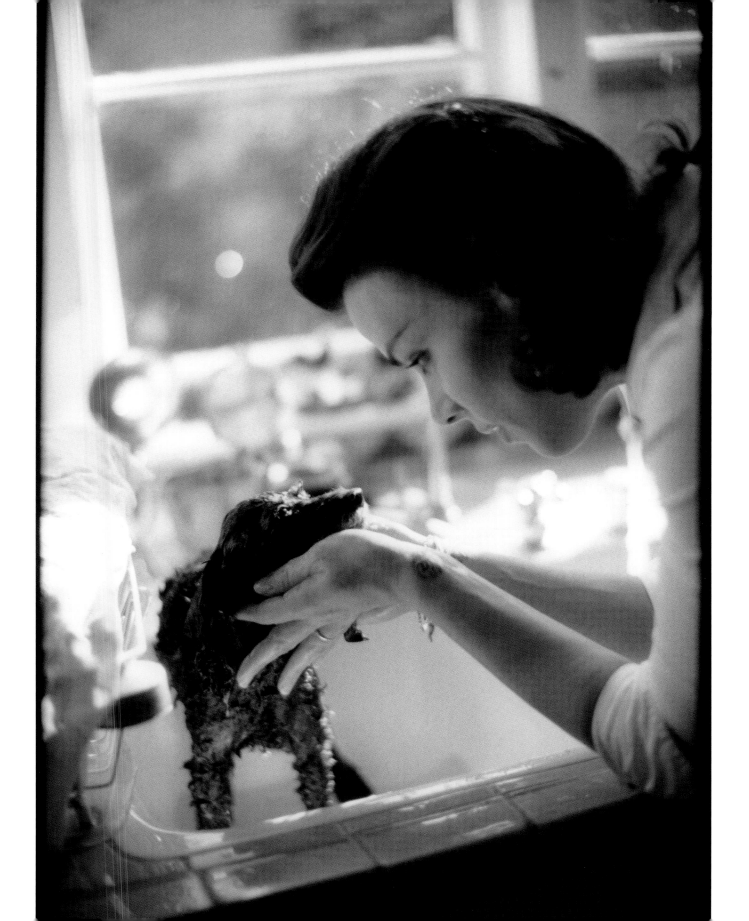

Melissa Rivers, TV personality

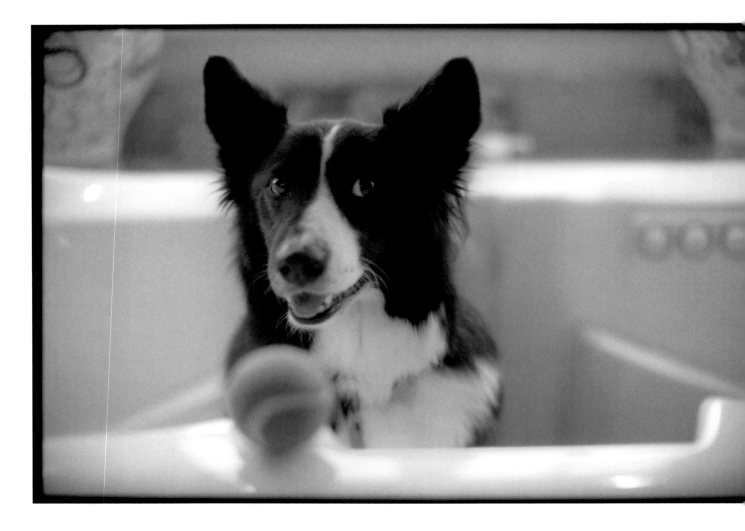

*"There is no companion as faithful as my rescue dog, Mike.
He is always there for me no matter what, and his love
and patience bring me happiness every day."*

Melissa Rivers

I love my
dog! ♡ !

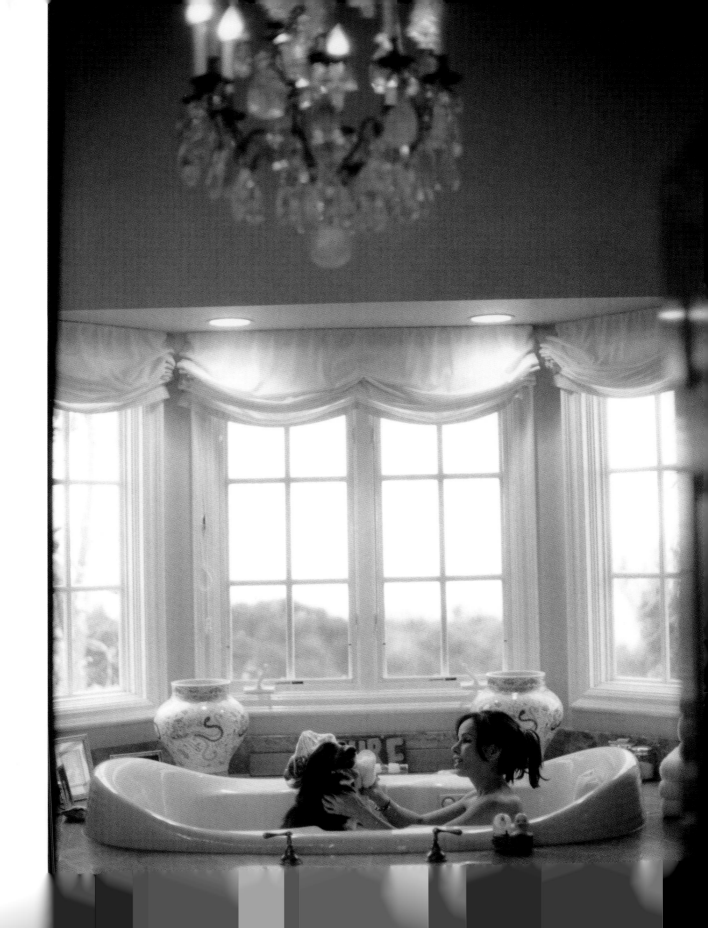

Blaze, NYC K9 Unit

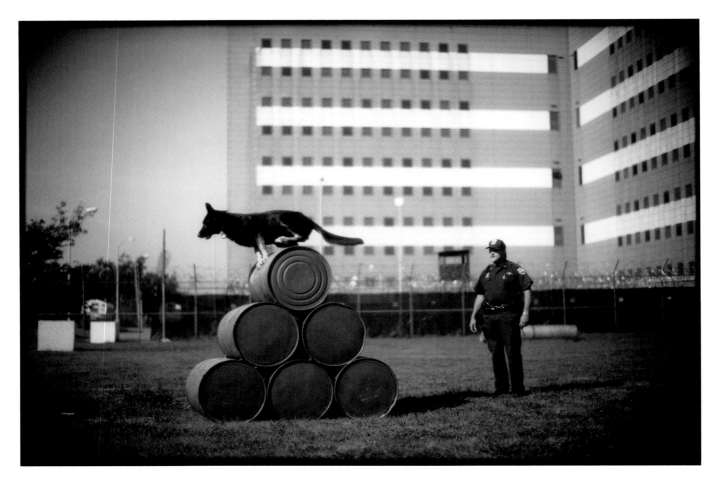

NYC K9 UNIT

CAPTAIN

[signature]

K-9 1

CANINE BLAZE
*K1

All sorts of dogs, purebred and
mixed breed, excel at agility trials;
why not see if yours is one of them?
—THE HUMANE SOCIETY OF NEW YORK

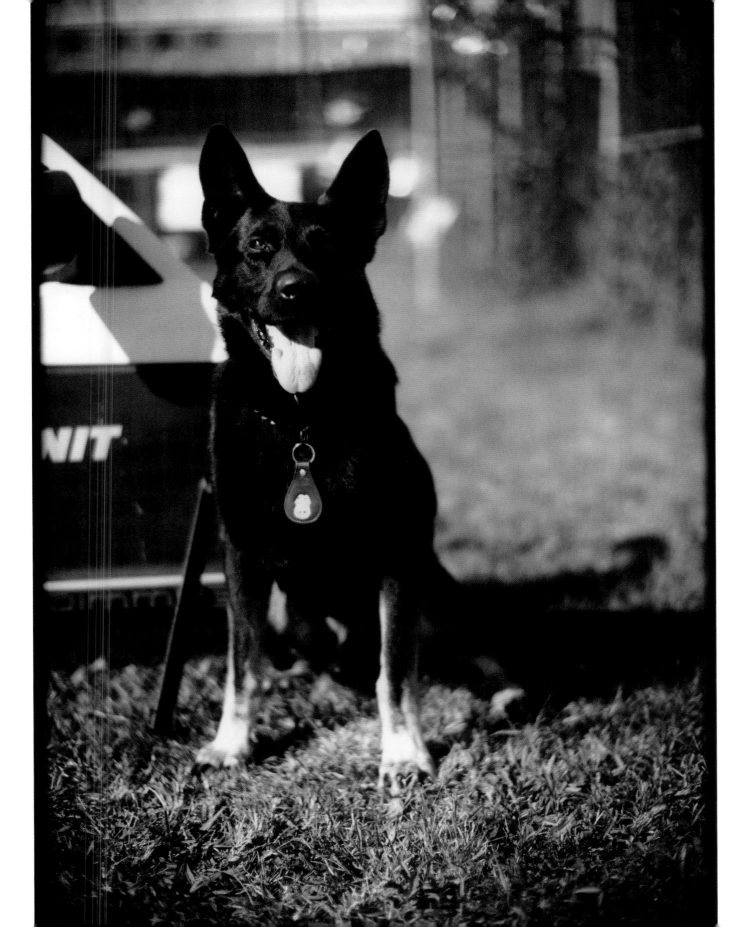

Rachael Harris, Actress

What do chocolate,
raisins, and onion
rings have in common?
They're tasty treats
for humans, but they
can be deadly for dogs.
—THE HUMANE SOCIETY OF
 NEW YORK

Roscoe & Mable

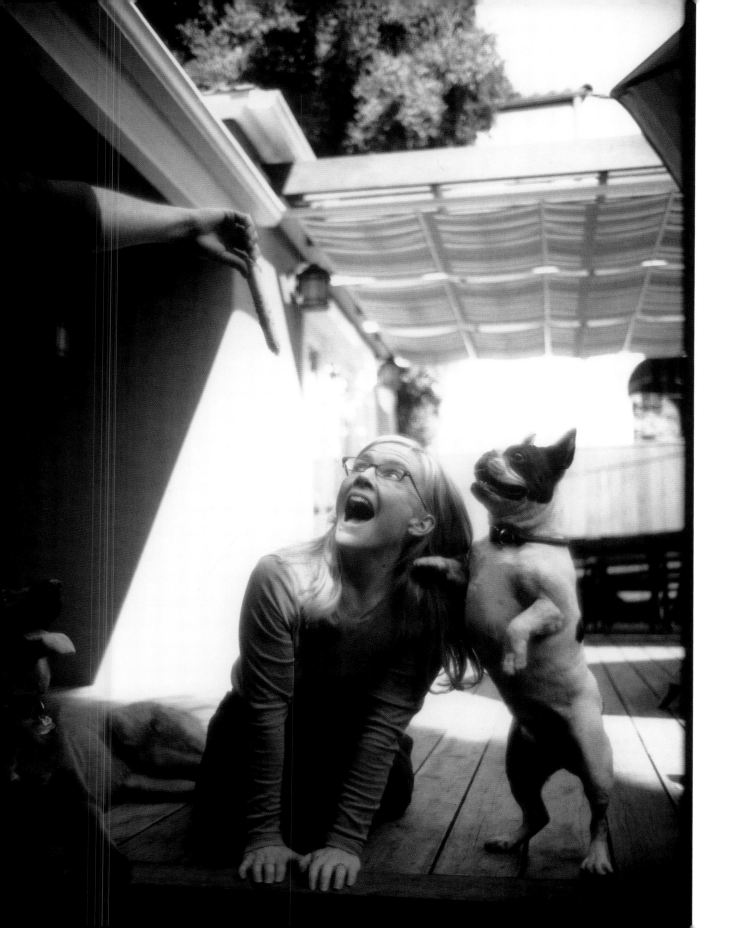

Jennifer Esposito,

actress

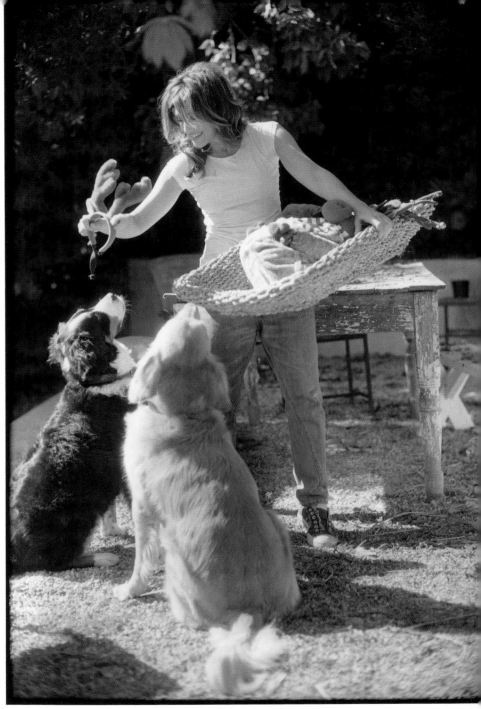

Jennifer Esposito

Frankie Beans and Betty Boop
Have been my best friends,
family and loyal pals!
I love them dearly!

Constance Zimmer, actress

Rescue Dogs Rule!
Much Much Love
 from Much♥!

Constance Zimmer

There's nothing like a hound dog/collie/shepherd/Pekingese/
poodle/retriever/dachshund/pug. Consider adopting a glorious mutt.
—THE HUMANE SOCIETY OF NEW YORK

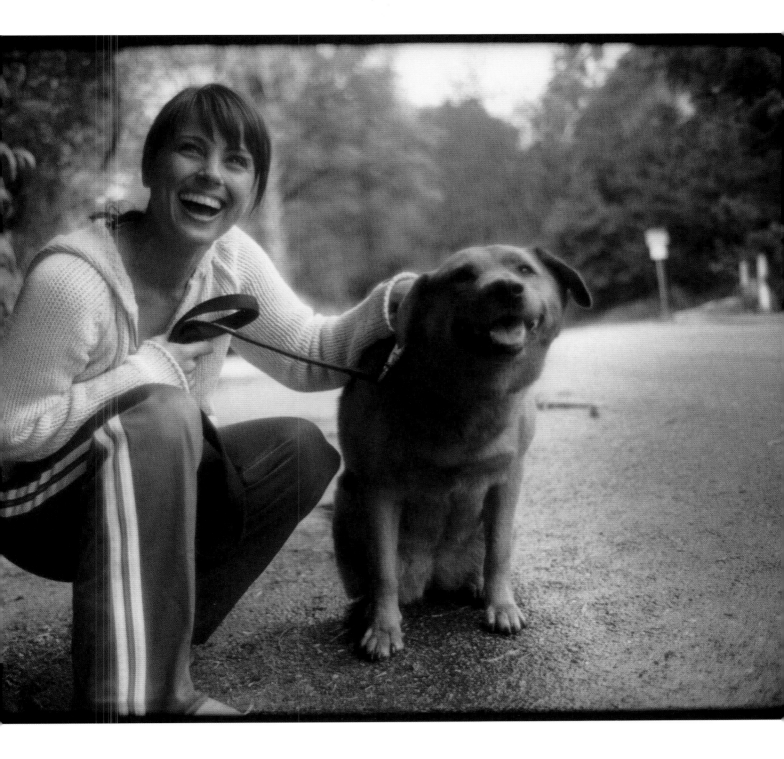

Cheyenne Jackson, actor and singer

XO,
Cheyenne Jackson
and
Zora, the New York Girl!

Size isn't always the best indication of how much exercise a dog needs. For example, while a Jack Russell Terrier isn't much bigger than a cat, he can wear out a triathlete. So think carefully when choosing your perfect match.
—THE HUMANE SOCIETY OF NEW YORK

Bethenny Frankel, chef, TV personality, and author

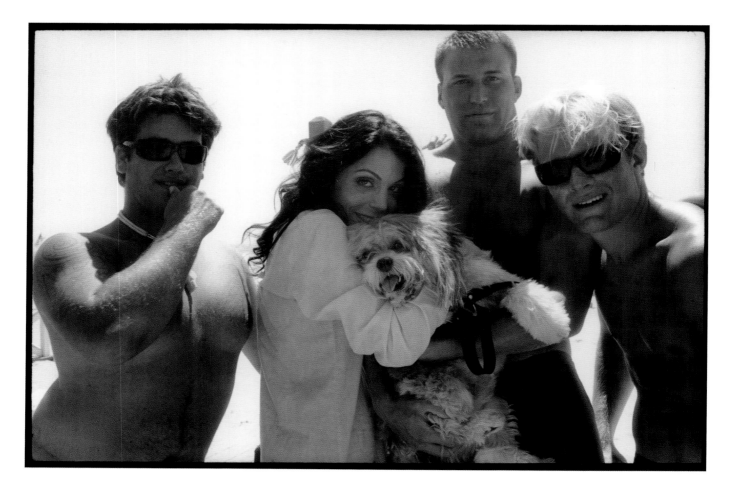

"Cookie is my family. She warms my soul."

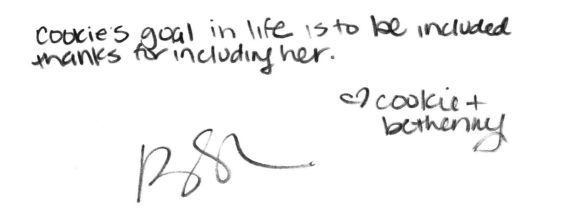

cookie's goal in life is to be included
thanks for including her.

♡ cookie +
bethenny

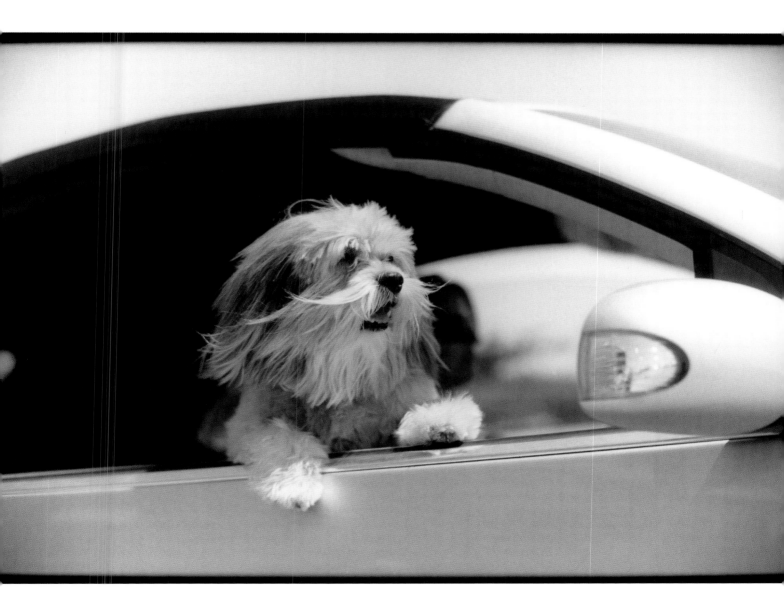

Beth Ostrosky Stern, model, television personality, and spokesperson for the North Shore Animal League

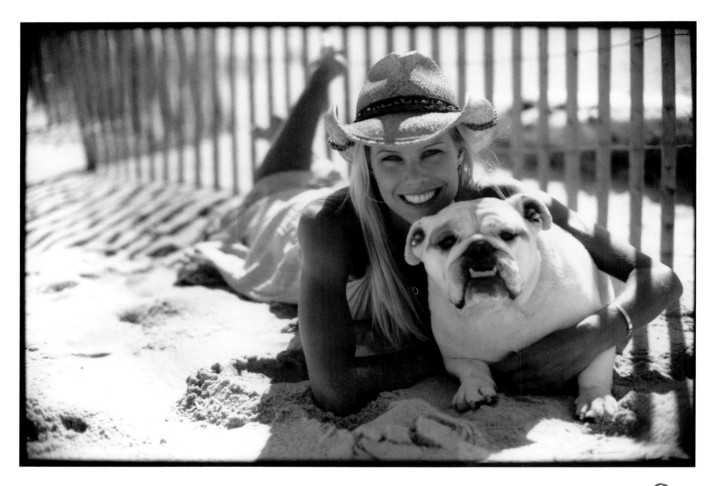

"Bianca sees beauty in everyone and everything, is never judgmental, and takes all the time in the world to walk around the block. She's taught me that nothing in life should be rushed, and to take time to just enjoy each day."

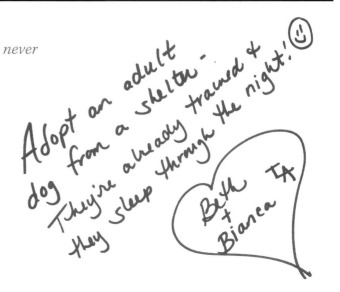

Adopt an adult dog from a shelter— They're already trained & they sleep through the night! ☺

Beth + Bianca ♥

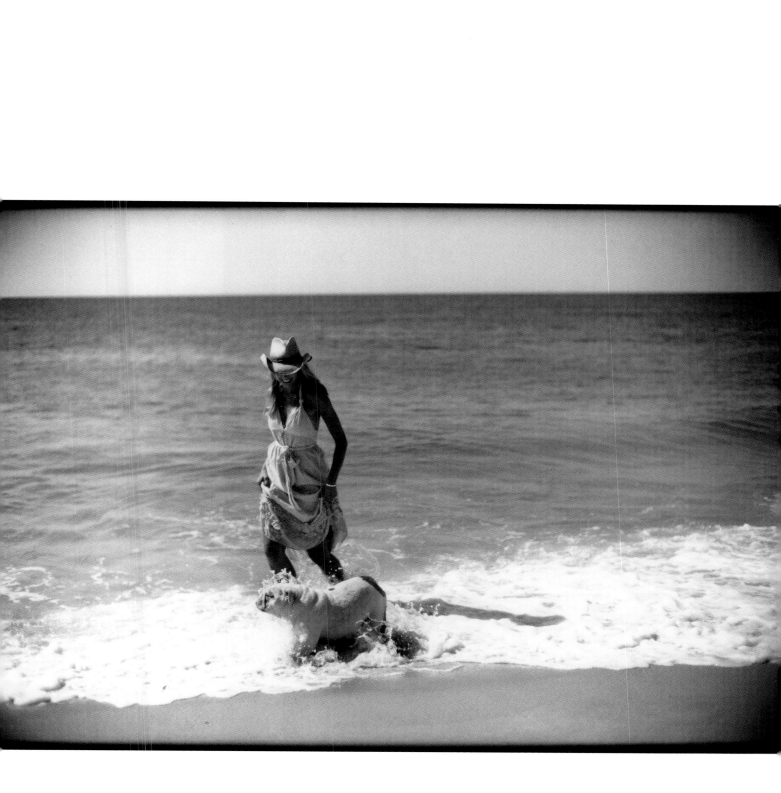

Lori Levine, founder and CEO of Flying Television

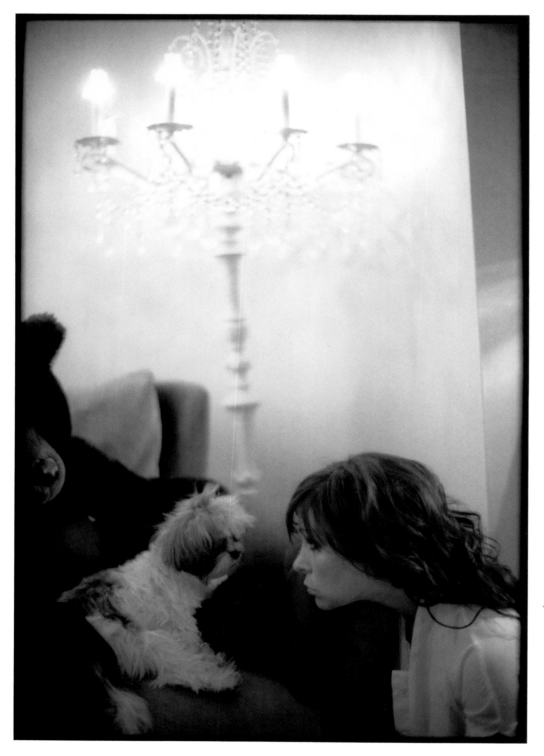

"Suki is completely fearless, looks you square in the eye, and will always run towards you, rather than away. She's my hero (except for her breath— that's just awful)."

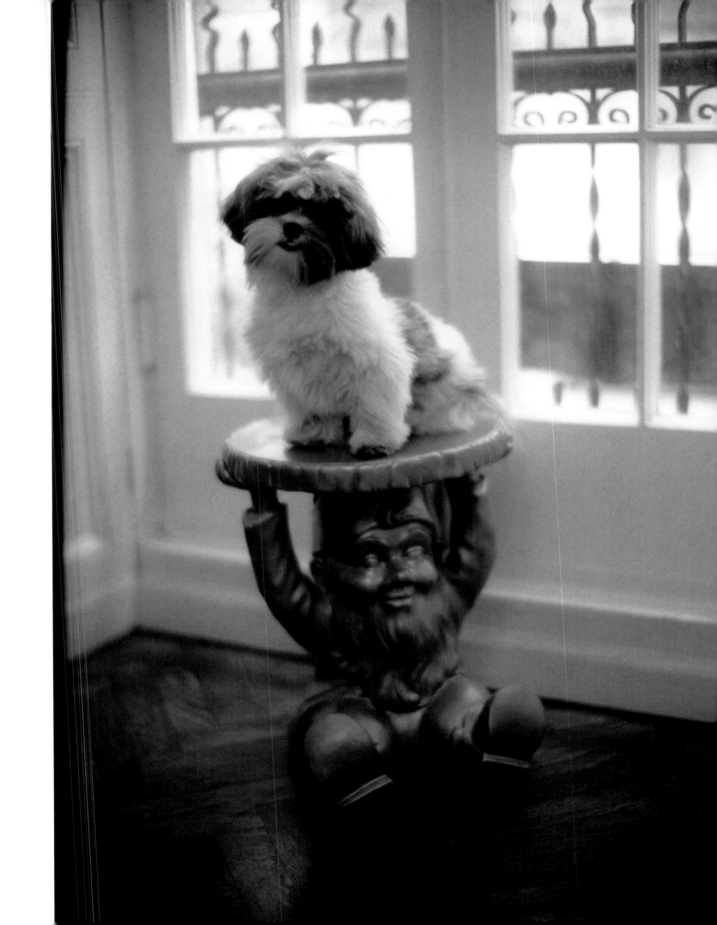

Chris Meloni, actor

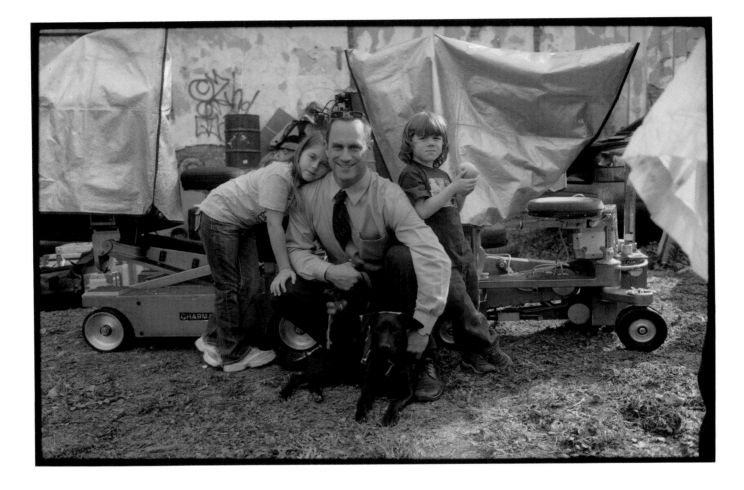

"All she has to do is wag her tail and I smile—easy, priceless happiness."

FRIDA - BROKEN LEG,
BEAUTIFUL SPIRIT
DAUGHTER NAMED HER
AFTER THE PAINTER

Chris Meloni

Denise Richards, actress

my dogs, pigs, + cats put a smile
on my face everyday. Pure, unconditional
love

♡ Denise Richards

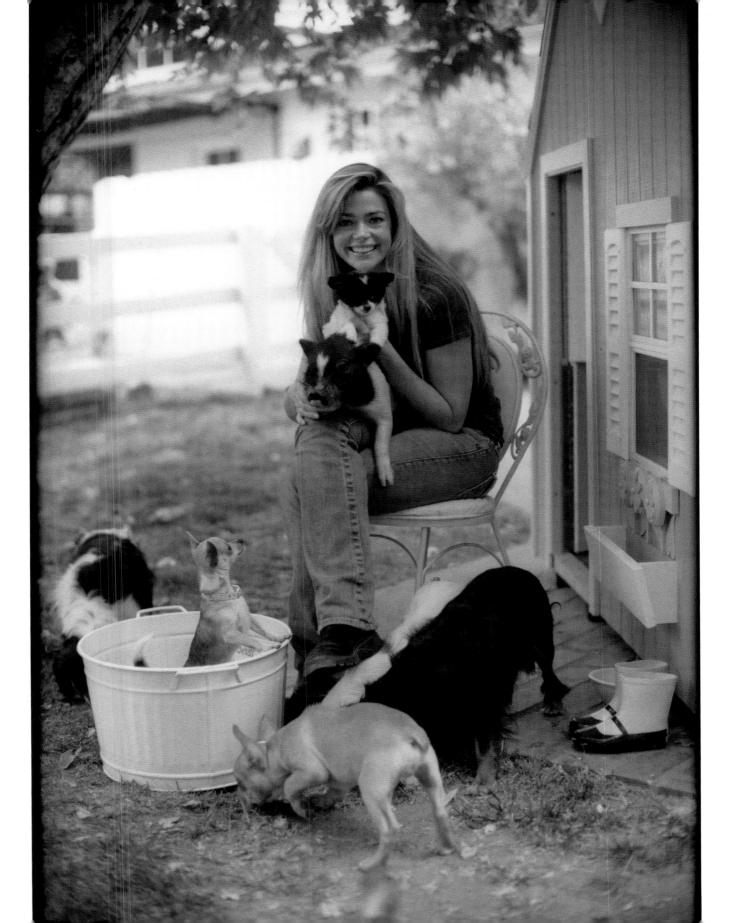

Gregg Oehler, executive director, PetStyle, and
Belinda Johnson, model

Gracie — She gave me
patience & changed my life.

Gregg R. Oehler

*"Gracie has helped me learn the true
meaning of compassion."*

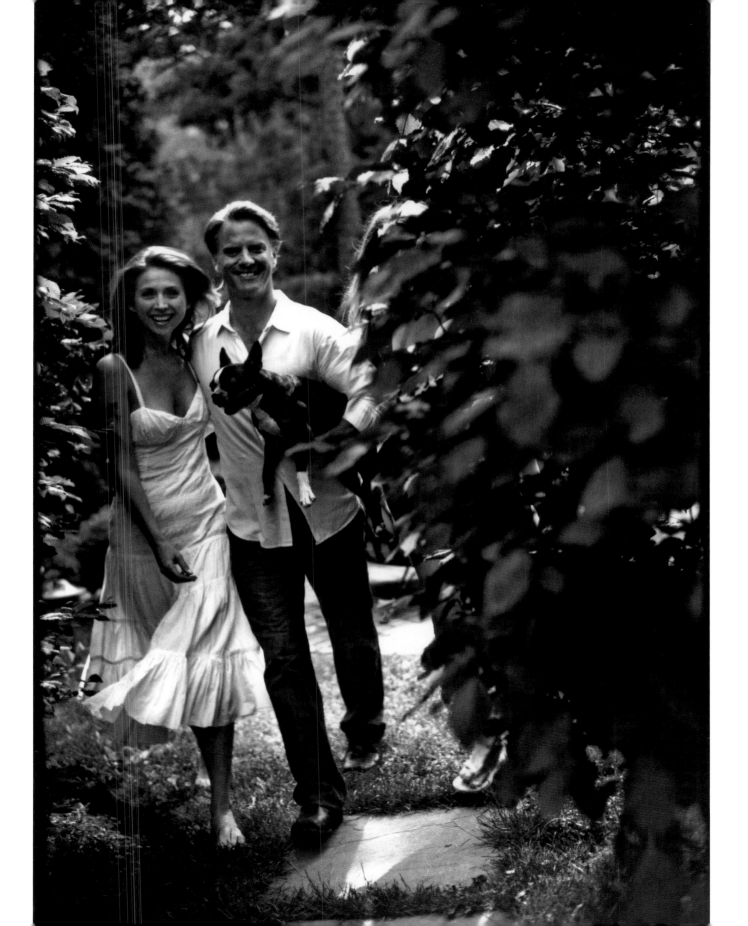

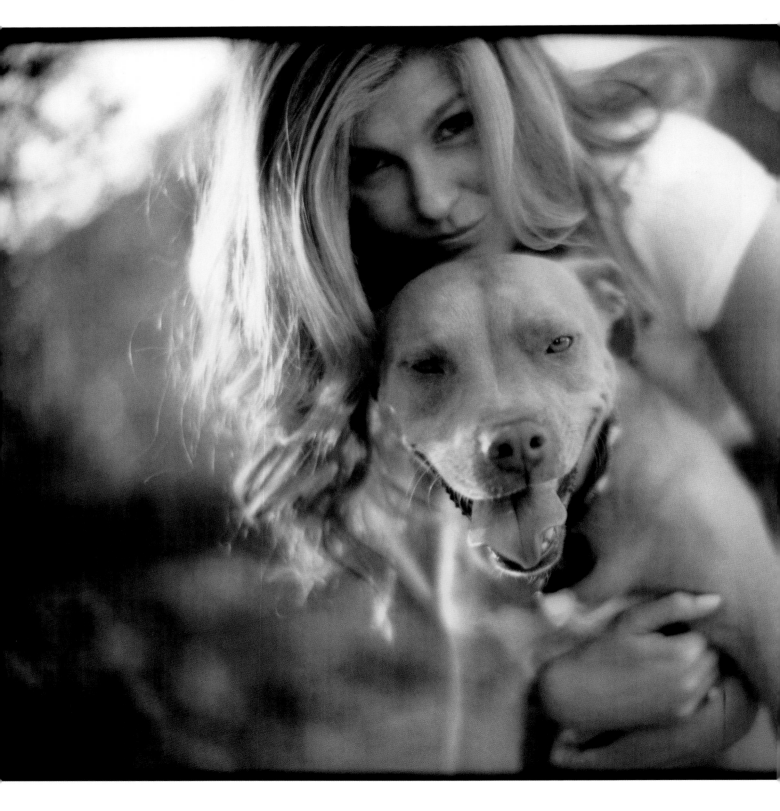

I love Lucy!!
Named Lucy ... because she was loose!!
So glad you found me, sweet girl..
♡ Connie Britton

"Lucy reminds me that almost anything can be interesting . . . or at least worth a good sniff. She also helps me remember that you can be strong and still have a smile on your face like she does, all the time."

Selita Ebanks, model

"I travel a lot for photo shoots, and I always look forward to returning home and hearing the dog tags of my pup Prince as he comes to meet me at the door. No matter how long the flight has been or how tired I am, I'm never happier than when I see him."

Prince & Prince Jr.
Best wishes!
Selita E.
Dogs Rule!!

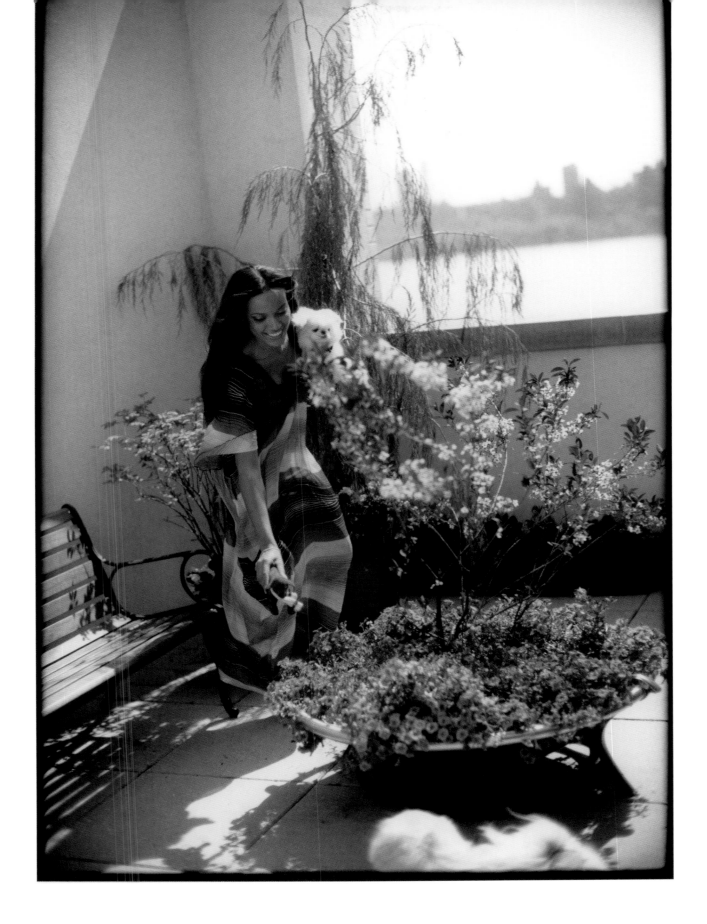

Jennifer Westfeldt, actress

Jennifer Westfeldt signature

Cora
Hammfeldt 😊

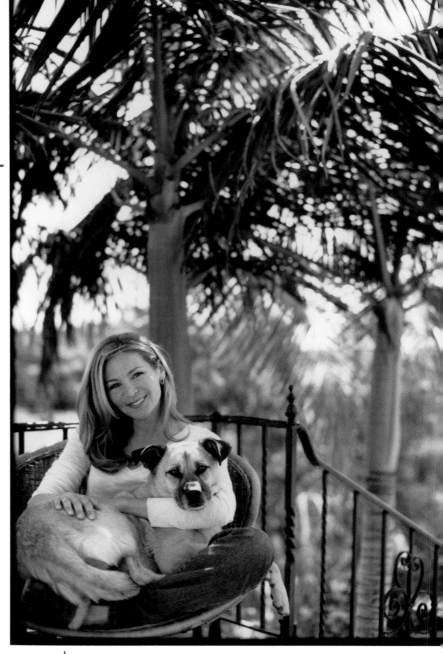

Cora
Hammfeldt,
Rescued from Death Row
@ South Central Pound—!
Now happily ensconced,
as the love child
of Jon Hamm
+ Jen Westfeldt,
5 years
+ counting...
xxx

Brooke Smith, actress

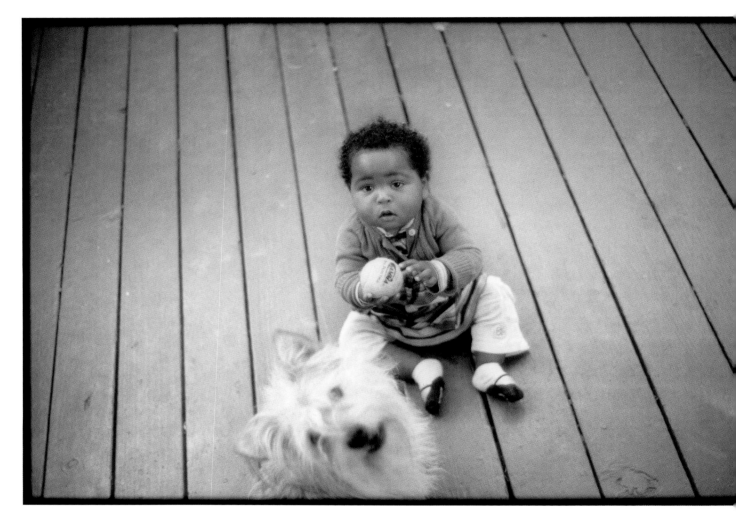

Brooke Smith

we rescued Stitch
then he rescued us...

☺

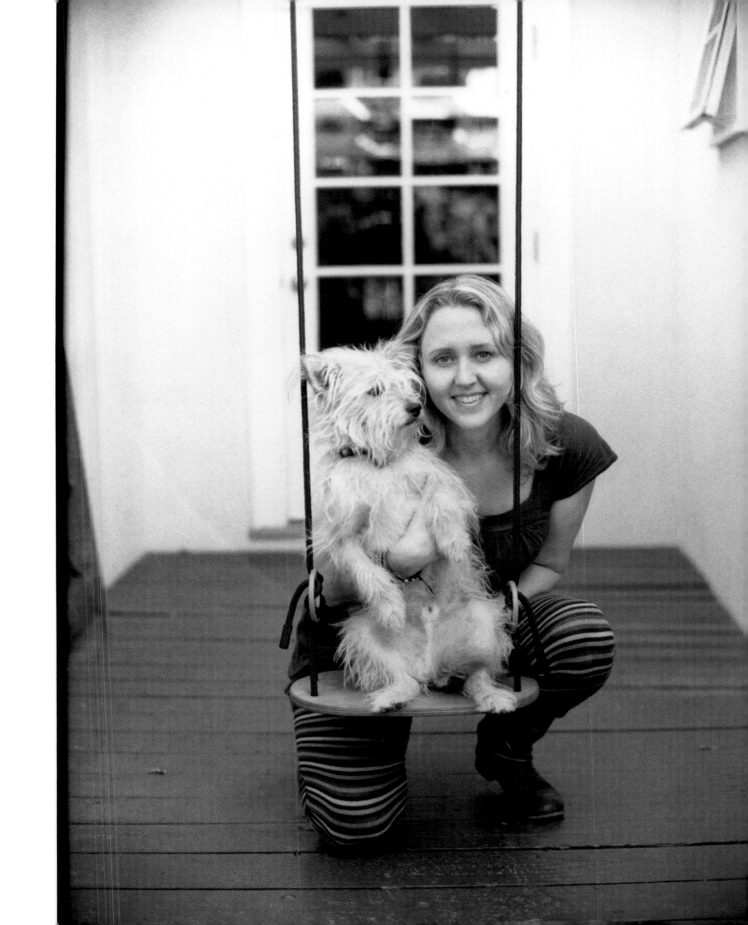

Kylie Bax, model and actress

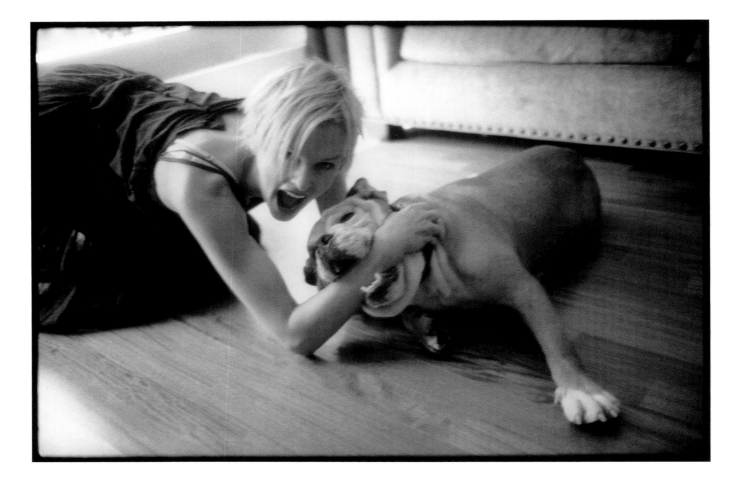

"*Flash Gordon has helped my family by sharing his enthusiasm for life, allowing the kids to pull his ears whenever they feel like letting out a little aggression, and simply being a great guard dog, pal, and protector of our home.*"

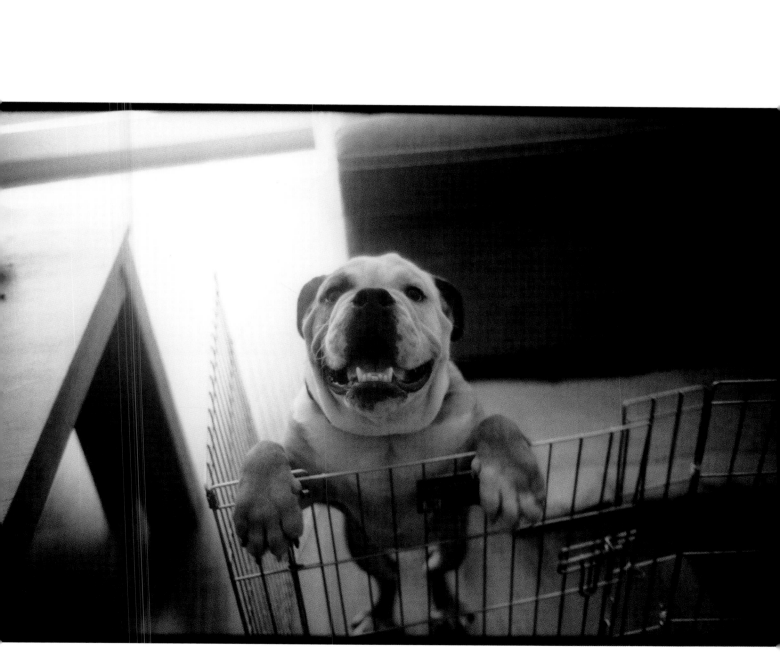

Maggie Rizer, model, actress, activist

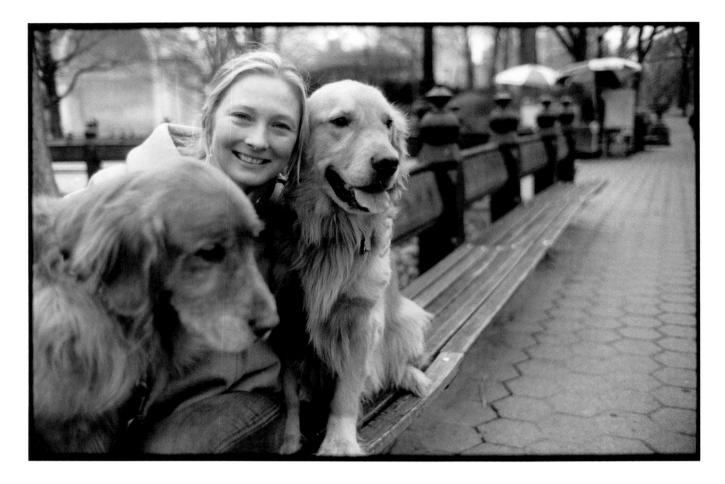

*Maggie Rizer
and sons
Henry & Albert*
*We ♥ the Humane
Society* :)

*"Henry and Albert make talking to myself
(which I do constantly) acceptable. I talk
to them and ask them questions—it just
gets scary when I answer myself back,
pretending to be them. . . . Life is fun with
my dogs; I'd be boring without them."*

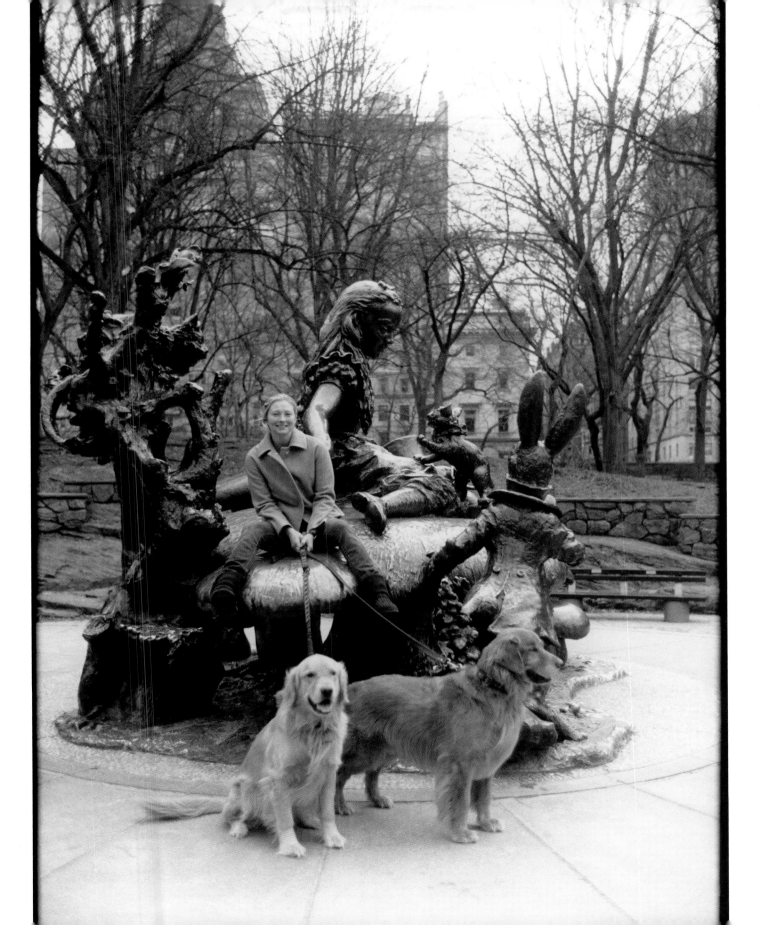

Eliot Ferguson, drummer for Gogol Bordello, and
Jennifer Sample, director of advertising for *Paper* magazine

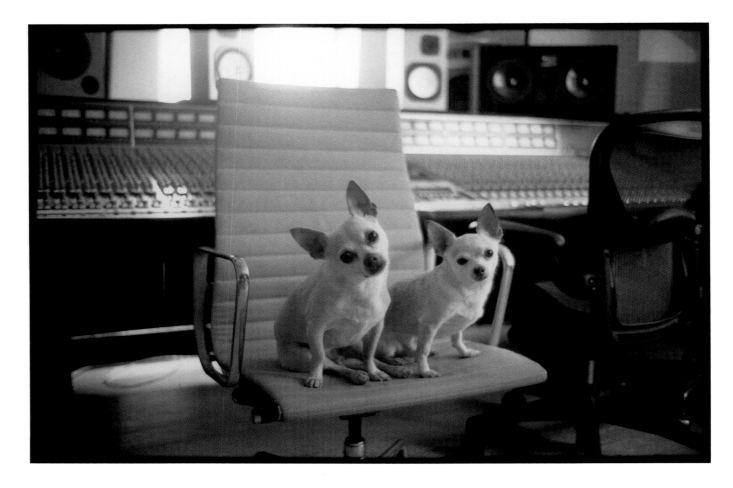

"They've given us a shared language, born out of their unique personalities, and the ongoing construction of this language brings us closer together every day."

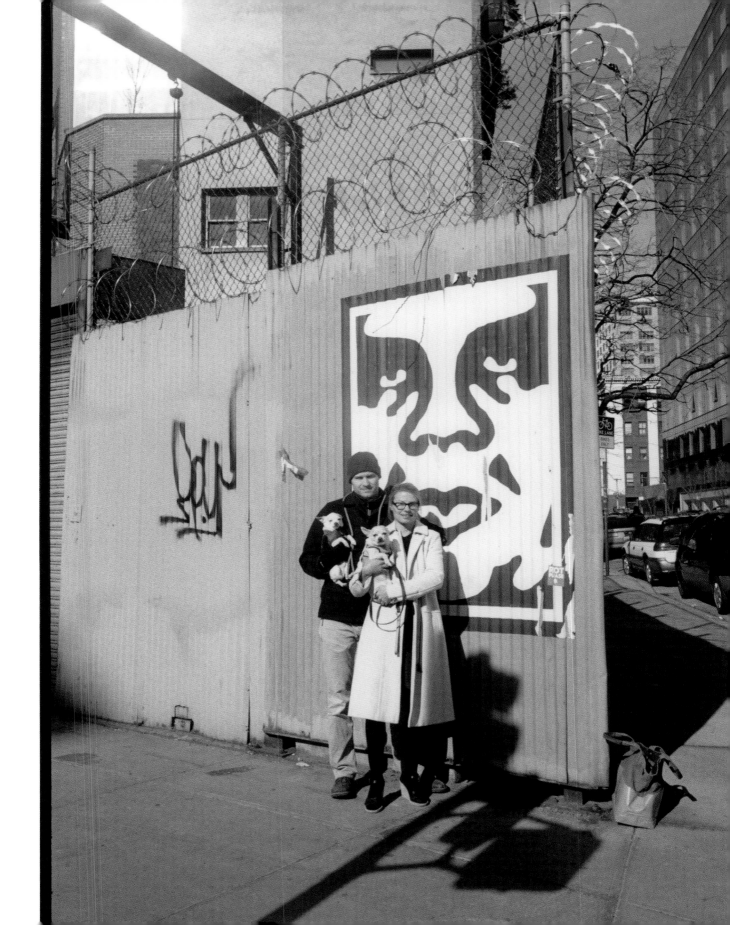

Emily Sandberg, model

Theo is also a WonderDog! M

"Theo helps me keep it simple:
coffee, conversation, and companionship."

Don Nice, artist

don nice
and girl

"Girl is a wonderful distraction."

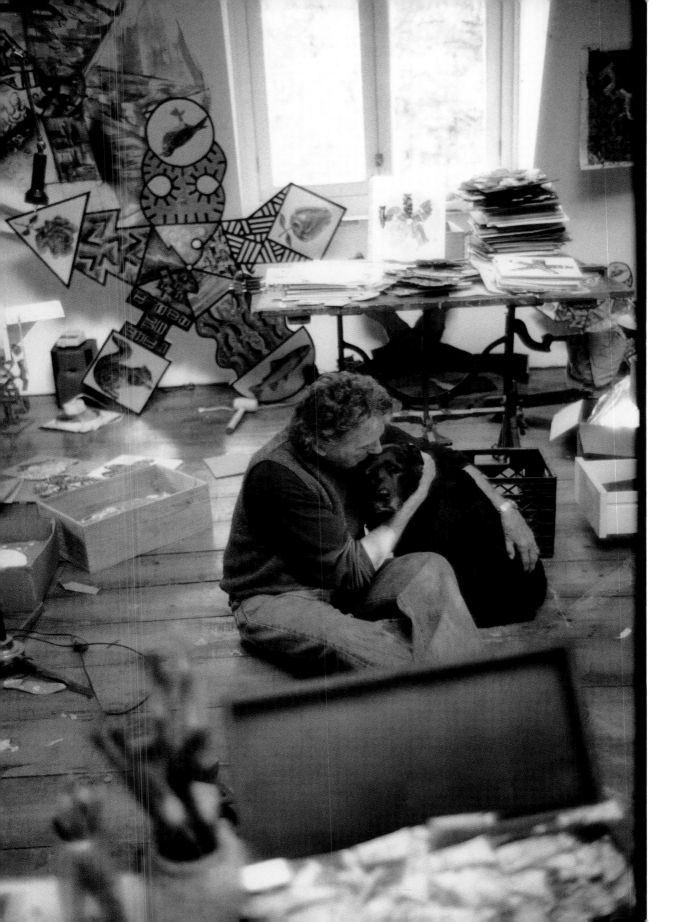

ACKNOWLEDGMENTS

THANK YOU TO all of the participants for taking time out of their busy lives to help make this book possible, as well as their agents.

A special thank you to Lori Levine from Flying Television, who came on board halfway into the project and helped me through the rest of it pro bono.

Thank you to Beth Ostrosky Stern, who introduced me to my publisher, Jennifer Bergstrom, and my editor, Emily Westlake, at Simon & Schuster. Thank you, Jennifer and Emily, for making this happen. Thanks also to my literary agent, Farley Chase at the Waxman Literary Agency.

Thank you to the following people who led me to the subjects in the book over the course of three years, who let me sleep on their couches or in their guest rooms, who fed me, and who listened to me. (Yes, it's done!) Greg Morancey, John Lynch, Rick Russo, Jean-Pierre Marois, Mary Catherine, Frances Manzi, Martha Bramhall, Tricia Helfer, Michelle Icahn, Dawn Jacobson, Catherine McCord and her family, Graham Shearer and his family, Dan and Ella Stoloff, Kimberly at Industria Super Studio, TriStar Management, Ro and John Scollan, Megan and Dan Neuman, Al and Margaret Kennebeck, Jason Sica, Cheryl Marks, Michael Farkas, Helen Storey, Lewis and Audra at LVA Represents Inc., Anne Marie, Don and Sandra Nice, Leslie, Samantha, Macdara, Devin, Heanue, Courtney and Sam Nice, Justin, Bryan, Remy, Sarah Gore Reeves, Jetty Stutzman, Gee, Ruthanne Secunda, Elizabeth Much, all the hair and makeup people who gave their time, Dr. Sapienza, Sandra DeFeo and Virginia Chipurnoi at the Humane Society of New York, Stacy Bodell at Much Love Animal Rescue in Los Angeles, and Gus Kayafas and everyone at Palm Press.

I also want to acknowledge the people and pups who have passed away during the making of this book, including Deirdre Todaro, who found many of the participants for me and who dearly loved dogs. They will live on in *Rescue Tails* and continue to help our canine friends.

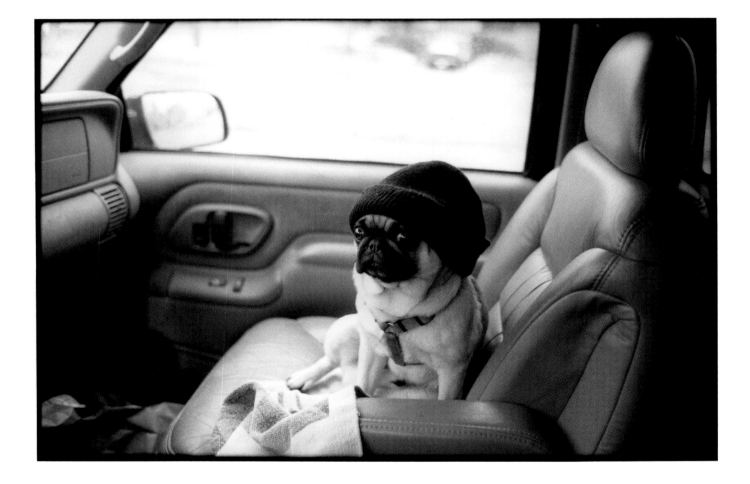